TR
23
.M33 Maddox, Jerald C.
1989
 The pioneering
 image

$29.95

DATE			

THE PIONEERING IMAGE

THE PIONEERING

IMAGE

CELEBRATING

150 YEARS OF AMERICAN PHOTOGRAPHY

Jerald C. Maddox

Universe

With special thanks to
Margaret E. Wagner

Published in the United States of America in 1989 by Universe Books
381 Park Avenue South, New York, N.Y. 10016
© 1989 Universe Books

89 90 91 92 93 / 10 9 8 7 6 5 4 3 2 1

Printed in the United States of America

Library of Congress Cataloging-in-Publication Data
Maddox, Jerald C.
 The pioneering image : celebrating 150 years of American
photography / Jerald C. Maddox.
 p. cm.
 ISBN 0-87663-695-4
 1. Photography–United States–History. I. Title.
TR23.M33 1989 88-32512
770'.973–dc 19 CIP

Designed by Stephen Fay

One Hundred Fifty Years
of
American Photography

Nineteen hundred eighty-nine marks the 150th anniversary of Louis Daguerre's public introduction and demonstration of the first practical photographic process. It was received with enthusiasm and quickly spread through most of Europe, touching and fundamentally changing many aspects of society and culture. By the end of the year daguerreotypes were being made in the United States, and photography was to have as significant an influence there as in Europe.

Photography began as a technology that recorded visual realities as they are perceived through a lens, but quickly moved away from this basic function into sophisticated areas of art and expression. It has also become the universal folk art, one accessible to many and practiced by millions. In virtually every society and culture in the world, photography and photographic perception have become the fundamental form of expression and communication, perhaps even surpassing reading and writing. It has revolutionized the way the world is encountered and remembered, and this has been evident from the beginning. At the same time, however, photography is a reflection and record of the world, and as much as it has shaped the world, it has itself been molded by this same world. Perhaps this is no more dramatically seen than in the ways photography evolved in the United States and Europe, beginning as it were on an almost equal footing, but producing over the years a body of images at times strikingly different in their form and content.

These differences began to appear almost as soon as photography began to move out of its early experimental stages. Photography was introduced to the United States by men like Samuel Morse, who can be described as scientifically curious amateurs, mostly interested in theory and research. Very quickly, however, it was taken up by individuals with a more practical end, who approached it with an eye toward entrepreneurial applications. One of the first was Mathew Brady, who may have learned the process from Morse. Brady very quickly found success with his portrait studio, and produced images that were admired and praised in the United States, and also in Europe, where his work won many prizes in competitions. In his attitude and approach to the medium, Brady was typical of many American photographers, and while they were not unaware of the aesthetic and documentary aspects of the medium, the fundamental view was that photography was a tool for producing a product to be sold.

Although it cannot be said that Europeans were unaware of the commercial potentialities of photography, there was still a marked difference in the ways it was fitted into the culture. To a much greater extent than in the United States, photography was seen in the context of the older visual arts, drawing from them for both form and content and reflecting a definite cultural tradition.

Much of this difference can be seen in the person of Roger Fenton, a major figure in the early history of the medium, and a contemporary of Mathew Brady. Consider that while Brady was establishing his reputation as a portrait photographer of the open democratic society of the United States, available to anyone who came through the doors of his studio with enough to pay for an image, Fenton was photographing objects from the collections of the British Museum, and making studies of the children of the Royal Family. A more interesting comparison is found, however, in the bodies of work for which each man is best known – Fenton's Crimean War photographs, and the images of the American Civil War associated with Brady.

Roger Fenton went to the Crimea at the request of the British government to produce a visual record which could counteract criticism of the handling of the war. His some 350 images are for the most part group portraits of officers, or general views of the landing areas and the camps. There are virtually no pictures of battlefields, none of dead or wounded soldiers. They are artistically pleasing images that present a rather positive view of the war and give us some notion of the manners and lifestyles of the British upper classes. Some of the limitations of Fenton's work can be attributed to the restrictions of photographic technology at that time, which required long exposures and tedious processing, but there is also no question that these pictures were meant to show a particular view of what was going on.

Compare this with the undertaking of Mathew Brady just a few years later and one is overwhelmed by the differences in the scope and ambition of the two projects. Although Brady was far from being the only person involved in photographing the Civil War, he was certainly a primary force in setting such photography in motion and in carrying it through. The most active photographers all had some connection with him and his studio, and he was the one who envisioned a large and comprehensive effort of documentation. While Brady was undoubtedly aware of the historical importance of what he was doing, he also thought of it as a potentially profitable business venture. As it turned out, the historical significance turned out to be much greater than the financial for Brady and for most of those involved in the making of these images.

Hundreds of photographs were made, probably several thousand total in the end if all the carte-de-visite portraits are included. Within the technical limitations of the medium, all aspects of the war were shown, including some that were shocking to the public. For not only were the generals and heroes shown in their splendid uniforms, but also the rows of dirty and mutilated bodies amid the terrible devastation which was the truer aspect of that war. In the context of that time, these pictures brought the war to a general public with a degree of reality previously unknown. The only important aspect that photography was unable to show was the movement and action of actual battle. The effect of these photographs remains strong today, and they stand as one of the uniquely identifiable parts of American photographic history.

Civil War photography also had a major effect on the next significant body of work that is unique to the history of American photography. After the war, the country returned to its western expansion, which was led by several government-sponsored expeditions into the unknown territories. These were accompanied by photographers, and in several instances they were men who had been active during the war. The difficulties encountered in battlefield photography were excellent training for the work in the wilderness of the West. The landscape they encountered was unlike anything known in most of the older portions of the country and Europe. It was dominated by great expanses of space and filled with natural formations of unusual shape and size. As it had with the war, photography brought this to a wide audience and intensified the level of interest in these new lands. Today, we are left with a body of images that are monuments of American photography,

and which have had a major influence on the medium, one that has continued to this day. In the 20th century the photographs of Ansel Adams evolved from these earlier examples to become a major expression of American art, and have defined and established a tradition still present in contemporary photography.

It is interesting that just as the great period of western survey photography was ending in the 1880s, another far-reaching phase of the medium began. This is one that is not so much a matter of images as it is of methods. It was this period that saw a great technical simplification of photography and the beginning of large-scale promotion of amateur picture-taking. It was this period that saw the introduction of the first Kodak snapshot camera, and the beginning of industrialized, mass production of images. On one hand, this may have been bad for the established, professional photographic craftsman, since it decreased the demand for some of his products. On the other, there was a widening of the audience for images to an even greater extent, and the appearance of individuals who made photographs as ends in themselves – not primarily as a matter of recording and documentation. This is not to suggest that no one was interested in the artistic aspects of the medium before this time. There were photographic societies in the larger cities where these things were considered and to some extent practiced, but for the most part the technical difficulties involved in securing a photographic image were such that most attention was given to dealing with these. It was only after the great simplification of technology that began in the 1880s that serious and widespread concern with aesthetic and expressive ends began to be significant.

To a large extent, aesthetic photography originated in the work of European photographers like Julia Margaret Cameron and Peter Henry Emerson. Educated members of the upper class, they had both the time and interest to pursue the medium as an end in itself. Through their work and in some cases through theoretical pronouncements, they brought a different approach to the consideration of the photographic image. By the end of the 1880s there were organized competitions and exhibitions of artistic photography in most of the major European cities. It was in this environment that Alfred Stieglitz – then a university student in Berlin – first established himself as an important photographer. Although there had been some activities of this type in the United States, it was only after Stieglitz's return to America in the early 1890s that artistic photography was articulately and strongly promoted. This was accomplished partly through exhibitions of his own work, but more importantly through his writing and editing, especially that done for the publications *Camera Notes* and *Camera Work*. Stieglitz was able to reach like-minded photographers from many parts of the country, and in 1902 he brought them together in a formal organization called the Photo-Secession. Although only a relatively few were formally listed as members, and an even smaller number were actually involved in the active functioning of the group, it was to have a tremendous importance for the development of artistic photography. Through its exhibitions and the publication *Camera Work*, this group consistently promoted and supported the notion that the photographic image is a unique form, fully as capable of being an expressive, creative vehicle as a painting or other form of imagemaking. One point that is especially striking as one studies the images of Edward Steichen, Clarence White, Gertrude Kasebier, Alvin Langdon Coburn, and the others associated with the Photo-Secession, is the range of form and style to be found. As if to answer one of the earliest criticisms made of photography as art, these works clearly show that this supposedly mechanical technology is capable of producing individually expressive images. This larger principle is perhaps more important than the ultimate aesthetic importance of any particular image produced by the group. It has remained to this day as a basic factor by which, to some degree, all photography, of whatever style or for whatever purpose, is evaluated.

Although the Photo-Secession was an international group, including foreign photographers like Frederick Evans, and frequently exhibiting its work in Europe, its primary significance has been in an American context. This is undoubtedly due to Alfred Stieglitz and his dominating presence. Through his writings and

the galleries he operated, he was a constant influence for art and photography in the United States until his death in 1946. This shows in the work of many photographers, including some not always associated with the fine-art ideals of the Photo-Secession. It is found in the images of Frances Benjamin Johnston and Arnold Genthe, both of whom had some connection with the Photo-Secession but are perhaps better known as working in a documentary tradition. Their work shows a care in making the picture that goes beyond simple recording – composition and light are carefully controlled and prints are made with care. In their work, and also in that of the early Edward Weston, there is a romantic quality which very much comes out of the turn-of-the-century aesthetics that were characteristic of so much of the Photo-Secession work.

To a large extent this approach was characteristic of much of the photography done in the United States through the 1920s and into the early 1930s. It is found in the work of these photographers, but also in the greater mass of commercial and advertising work that became more important during this period.

This can be contrasted rather dramatically with what was happening in Europe at the same time. There, as it had from the beginning, the photographic medium evolved as part of a larger cultural context. Contact with artists working in other media was commonplace, and there was a continuing exchange of ideas. The early 20th century in Europe had seen dramatic and revolutionary changes in the visual arts in matters of style and form, and these affected photography. Moreover, many of the artists involved in these changes moved from one medium to another and gave equal importance to all forms of expression, no matter what the medium. This European influence is found in the work of Man Ray, an American working in France. With its juxtapositions of unexpected forms and subjects, his photographs frequently show a connection to Surrealism. An emphasis on abstract geometric structure that suggests Cubist art is found in the work of Paul Outerbridge, who worked in both Europe and the United States and used many of these same concepts of modern art in his commercial advertising photographs.

As the 1930s progressed, however, the purely artistic aspects of photography were deemphasized as the medium began to reflect the economic and social problems of the time. A stronger notion of photography as a tool for communication and propaganda appeared, first in Europe and then in the United States. The primary vehicle for this material was the picture magazine, the best known in the United States being the publication *Life*. Beginning in the 1930s and continuing into the 1960s, this was the leading forum for expressive and committed photography and the work of photographers like W. Eugene Smith.

One of the most significant expressions of this approach to the medium was created in the United States in the body of work produced for the government by the Farm Security Administration.

Created to document and publicize the activities of an agency established to alleviate rural poverty during the 1930s depression, the photographic unit of the FSA went far beyond its original assignment and produced a body of work which became a major force in defining and directing the course of American photography. It was originally thought that photography would help the agency in its tasks by showing first what the problems were, and then, what was being done to solve them. The FSA photographs deal with specific events and individuals and provide information which at the time was important in dealing with these matters. These events, individuals, and actions have all become a part of history, and in some cases all that remains is whatever is recorded in the photographs. The FSA photographs are an unequalled resource for studies of many aspects of American life and culture, and at the same time, they are seen as works of art. This reflects the larger perception of photography that has evolved in recent years, but it is also due to the talents and interests of the individual photographers who worked on the project.

Most of the photographers who were involved with the FSA came to it with some notion of photography as art, and those who did not were to some extent influenced by the others. Some of the individual photographers have in recent years been considered and evaluated in a fine-art context, but the work involved

makes up relatively few images in a collection of some 75,000 items. Walker Evans–and, to some extent, Dorothea Lange and Ben Shahn–produced images that have become a permanent part of western visual history. Evans's studies of sharecropper families and of vernacular architecture are now impressed on the collective art consciousness, as are other pictures made for the program. In this context, Lange's "Migrant Mother" is very likely the best-known single FSA photograph.

The attention that is given particular images like those just mentioned illustrates a sometimes troublesome aspect of the photographic medium and one very characteristic of the FSA work. Does the designation as art of a few pictures from a much larger body of work have any bearing on the value and importance of all the other images in the collection or of the other works of the photographer? What does this mean in terms of establishing a definition of art? If only a few images are works of art, what are the others that were made at the same time?

Although it is probably not possible to answer such questions, the fact is that in the FSA project many of the directions, attitudes, and techniques that had been evolving in the medium from its beginnings were summarized and reconsidered. There is a basic premise as to what the concerns and subjects of photography should be–photographs are essentially to record, document, and visually represent a larger environment and society. This would seem to conflict with the objectives of photography intended as personal or aesthetic expression, and yet the FSA work shows how the medium can accommodate individual styles–the detailed precision and structure of Walker Evans or the more casual snapshot approach of Ben Shahn and Russell Lee. Despite the fact that their primary functions were to record and present information, all the FSA photographers were consciously making pictures, selecting material and transforming it, and in that fulfilling a major requirement of the activity that makes art.

It would be convenient to see in the photographs of the FSA and the concurrent centennial of the medium in 1939 a climax of evolution and development–photography had moved from its origins to maturity and established its own unique syntax. At the same time, it should not be suggested that the medium ceased to grow or expand from this point.

There was of course a pause and redirection of interests and efforts with the onset of World War II. During that brief and intense period almost all photographic activity was directed to ends having to do with the war. Other uses of photography were reduced, and materials and equipment became difficult to obtain for anything other than work associated with the war effort. Photography's documentary and reportage capabilities were in great demand for recording and propaganda, both in and out of the military, and photographers with widely varying interests brought their talents to this area. A photographer like Toni Frissell, known primarily for fashion and advertising work, became a war correspondent and produced striking images of the London Blitz–and the photographic section of the FSA was absorbed into and became a propaganda unit for the Office of War Information.

There is no question that things were not the same after the war, and the beginning of the second century for photography brought changes that continue to have an effect. All of the social, economic, and political forces that have shaped the world since World War II have affected photography as they have so many other aspects of our lives. More than anything else the effects of economic change have been telling for photography, as the years since the war have been a period of extraordinary growth and expansion with the development of a worldwide consumer-oriented economy that produces and uses an ever-increasing quantity and variety of goods.

This has affected photography in more than one way. The system that sustains and promotes this prosperous, consuming economy makes great use of photography as a primary tool in keeping the system active, and this period has seen a great expansion of advertising and fashion photography, both in quantity and quality.

The ubiquity of imagery that now exists allows photographs to go everywhere, giving photographers an almost limitless audience.

Along with advertising and fashion photography, photojournalism was prevalent in the medium during this period. Although the picture magazines had their origins in the years before the war, it was during the 1950s and '60s that they had their greatest success and influence. The best known of these were *Life* and *Look*. These publications were filled with photography: images were used as the primary means for conveying information in articles and advertisements. Their wide circulation helped to expand the awareness and use of visual communication that had been growing in our society since the invention of photography. It undoubtedly has helped to create a widespread sensitivity for visual communication and expression that has had an enormous influence on the perception and reception of the photographic image.

Amateur photography is a large and vaguely defined area of activity which has been a significant force since the introduction of the Kodak in the 1880s, and has frequently interacted with developments in commercial photography. This seems to have been especially true in the post-World War II period, for not only have people been exposed to a great flood of images in recent years – they have also been encouraged to participate in picture-making. There has been a continuing effort on the part of the photographic industry to simplify technology and make it easier to take pictures. Apart from technology, however, making pictures has become a very complex activity. It is not just a way of recording events and preserving memories; it is also a social activity. From the time of setting up, arranging, and choosing the scene and subject to the viewing of the finished image, it is an activity familiar to most people. As some aspects of commercial photography have declined – to a large extent because of television – the field of amateur photography has grown. The existence of this large and extensive involvement with images on all levels from making to viewing has contributed to establishing a receptive environment for another major development of the postwar years.

Art photography, here meaning photographic images consciously created as works of art to be experienced and evaluated in the same context as traditional painting and graphic media – as "museum art," so to speak – first became a widespread phenomenon around the turn of the century. Activity reached a peak in the first two decades, and then slowly declined as the photographic medium was utilized as a more general form of communication and expression. The notion of photography as fine art was gradually overshadowed by an increasing consciousness of its effectiveness as a vehicle for mass communication – an emphasis which was increased and sustained until the displacement of the print media by electronic imagery in the 1970s. In spite of this, during the 1930s and '40s, and later, the traditions of art photography were sustained by a few individuals, some of whom have become well-known figures in our cultural history. Edward Weston and Ansel Adams followed an approach to the medium that acknowledged the traditions exemplified in the work of Alfred Stieglitz. They thought of photography as a means for making pictures important in themselves as a form of expression.

After the war, more attention was again paid to such ideas, and the notion of photography as art for museums and galleries reappeared, and was strongly supported by the interest and efforts of institutions like the Museum of Modern Art in New York City. This revival of art photography was to some extent an evolution from earlier efforts like the Photo-Secession, but with significant differences brought about by cultural and social changes. One of the most obvious and important factors was the wide familiarity with photography that now existed and which had expanded greatly since the first phase of art photography.

Another factor – perhaps less obvious – came from the educational expansion that began in the postwar period with the return of thousands of veterans and the establishment of government-supported schooling. This began a period of growth that continued into the 1970s, and was not only marked by increases in the number of students, but also in the varieties and extent of kinds of subjects taught and studied. As educa-

tion moved away from established and traditional curricula, one of the new academic subjects was photography.

For the most part, these courses in photography were not primarily intended as vocational training, but went beyond that to create a larger and more general interest in the medium. Moreover, these programs were important for providing a professional structure where individuals were able to combine teaching with the practice of photography and pursue it primarily as a means of personal expression and art. Areas of concentrated interest and activity appeared around the country, usually centered about a particular teacher or institution. It is also significant that as this area was expanding, photojournalism, particularly as found in the large picture magazines, was reaching the height of its development and beginning to decline, losing much of its audience to television. In the world of commercial photography only fashion and advertising remained as an area where there was much place for creativity and personal expression.

The post-World War II revival of art photography was also greatly influenced by the appearance of a broadly based interest in all forms of art that led to the development of an active art market in many parts of the country. This would only seem a natural result of growth of a consumer society with increasing amounts of discretionary income. By the 1960s collecting art was ceasing to be an activity only for the wealthy, and more and more people of modest means became involved. At first interest was centered on the older media like painting, sculpture, and the graphic arts, but in the 1970s the photographic print began to be appreciated and presented in the fine-art context as an object valuable in itself and something to be collected. A highly competitive market developed in the late 1970s, bringing great increases in the monetary value given to individual photographs. To some degree it became an area for speculation, and the photograph came to be valued more as an artifact and less as a medium for conveying information or expressing ideas. At first most photography was shown in galleries exclusively devoted to that medium, but increasingly it has been shown in galleries with a wider and more traditional orientation. With its acceptance as a commodity in the established art market, it would seem the status of photography as art has been confirmed.

This is particularly interesting when considered in the context of history, for this acceptance of the medium was not without reservations—some of which persist even today. The hesitation about the medium to a large extent comes from its most fundamental characteristics—a technical accessibility that reduces the importance of the elements of craftsmanship and manual skill usually required in the other visual media and allows an almost universal participation in the picture-making process. This has produced a massive amount of imagery which seems to counter concepts of individual creativity. In spite of the implications of a publication like this book, photography is not on the whole a medium of "masterpieces." More often the strength of photographic imagery comes from its serial aspect and multiplicity of themes. In its earliest stages and through most of the 19th century, photography drew its principles and methods of artistic expression from the established media of painting and graphic arts. Its status as an independent art has been established only as photography moved away from the older media, emphasizing uniquely photographic qualities like the ability to record material realities with the greatest detail, pulling out of time and preserving particular artifacts and events with a completeness no painter or draftsman could match. That these elements would seem to have appeared so early and strongly in American photography might be attributed to some quality of native genius, but perhaps more realistic would be the physical distance from Europe and the lack of a strongly established native tradition in the visual arts. Whatever the case, the result has been that in the United States photography has evolved and assumed a position in the culture that is not matched anywhere else.

After 150 years, photography has been well established as a medium of communication and expression. It is universally used to record, transmit, and preserve visual information. It is a basic tool for shaping thoughts, opinions, and desires and is a significant form of artistic expression.

But, just as it achieves this position, photography is increasingly being affected by new technologies

that can fundamentally change it. This is already happening with motion pictures, where electronic video systems are now a primary way of recording images. The same technology is beginning to be used for making still pictures. Electronic systems of image-making may produce a picture perceived and transmitted through a lens and recorded in scales of continuous tone and value, but they do this with an immediacy and directness that alters the creative process. Throughout much of its history the photographic process has involved measured observation, action and reaction, and the appearance of an image in a passage of time. Much of that is gone with the new technologies, which produce a more abundant, but also perhaps more superficial, imagery.

It is a different imagery from that of the past, a hybrid vision drawing forms and structure from many sources into an electronic unity where distinctions between media are blurred, and the objective visual reality of photography can be combined with abstractions to alter perceptions and make a new reality.

Different ages find technologies to meet their needs – the mosaics at Ravenna and the frescos of the Italian Renaissance were suited to their times, and although mosaics and frescos have continued to be made, they have not been the fundamental media of communication and expression they once were. Photography has been a basic medium for communication and expression through much of the 19th century and most of the 20th, and now it seems this is changing.

It may be that photography is at the end of something, but the fact remains that in one hundred fifty years the medium has produced an impressive body of work. No matter what changes come, photography has been an important element in American culture and history, recording it and, possibly more than we realize, shaping it.

Modern printing technology has the capacity to reproduce with fidelity the details of texture, tonality, and contrast that form the basis of photographic imagery, but there are also limitations that should be kept in mind as one views the images in this book.

First, there is the matter of size: where all of the photographs shown in this book appear to be approximately the same size, the actual dimensions vary from about 3 × 4 inches for the Outerbridge "Umbrella" to 16 × 20 inches for the Watkins view of Yosemite, with most original images close to the standard 8 × 10 inches.

In addition, although all of the original photographs shown here can be described as black and white, it is more accurate to think of them as monochromatic, with the actual colors ranging from pale light brown and tan to rich sepia, and from subtle warm grays to cold blue-blacks.

The images that follow are drawn from and reflect
the scope of the photography collection at
the Library of Congress.

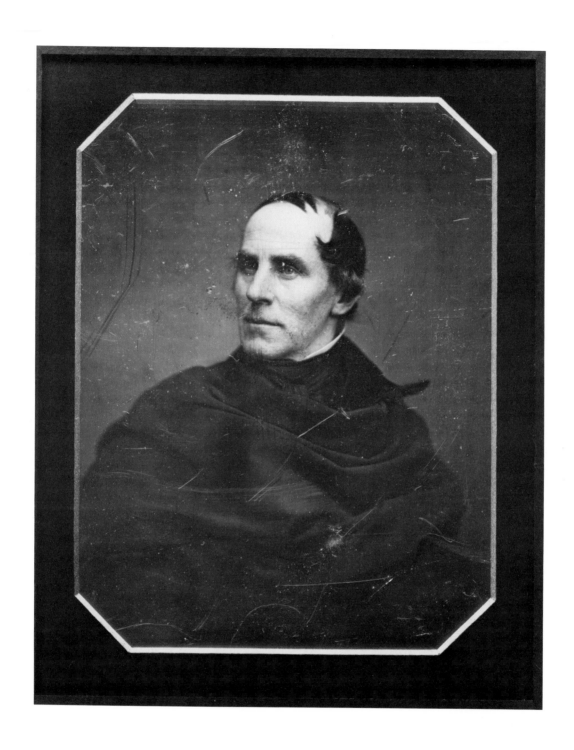

PLATE

1

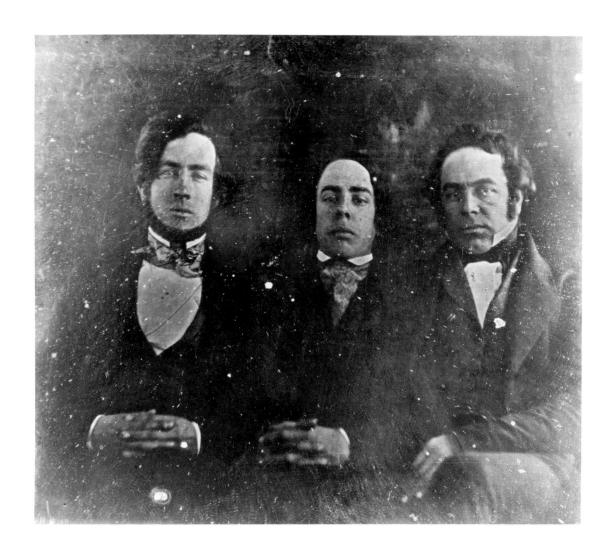

PLATE

2

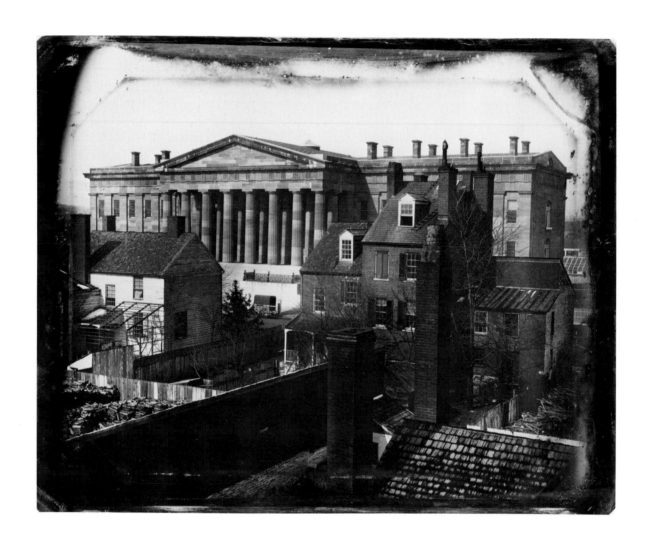

PLATE

3

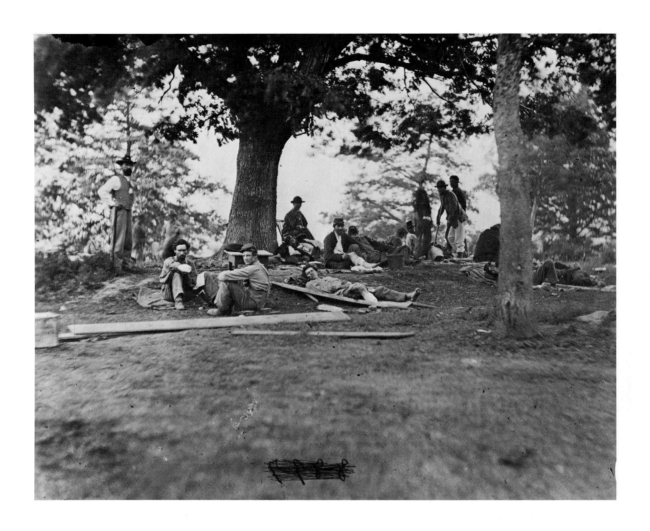

PLATE

4

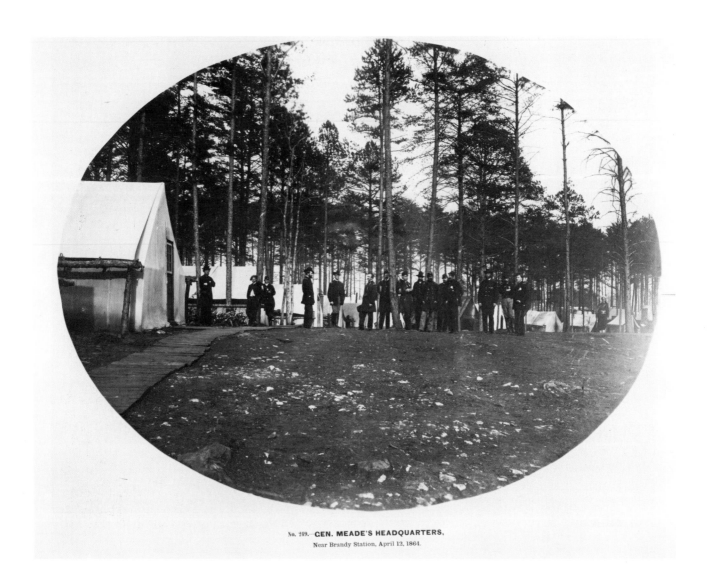

No. 249.—**GEN. MEADE'S HEADQUARTERS,**
Near Brandy Station, April 12, 1864.

PLATE

5

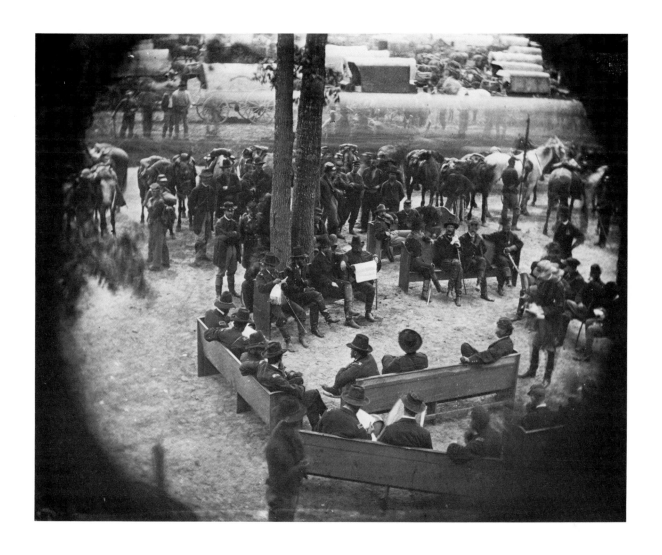

PLATE

6

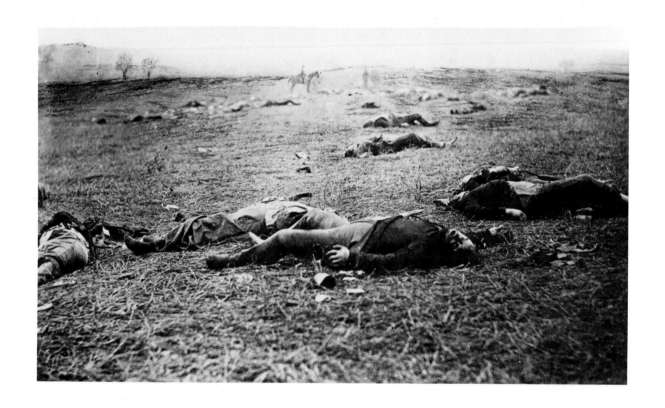

PLATE

7

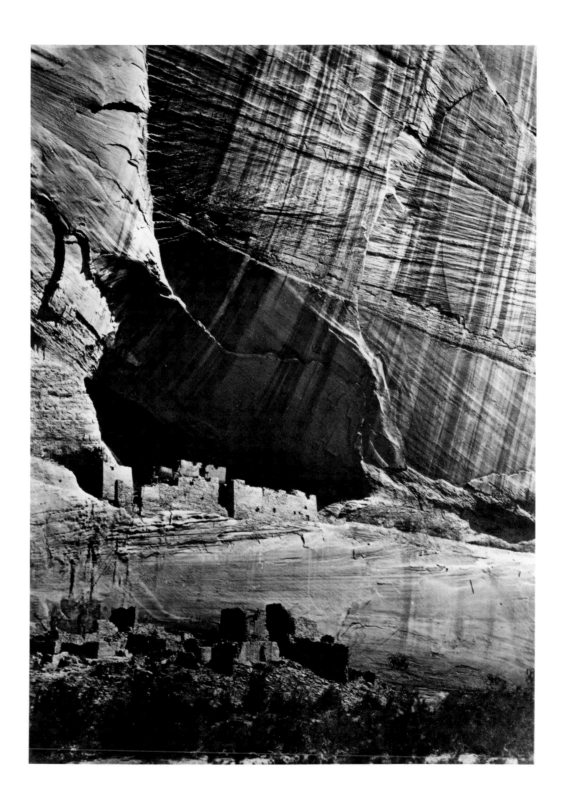

PLATE

8

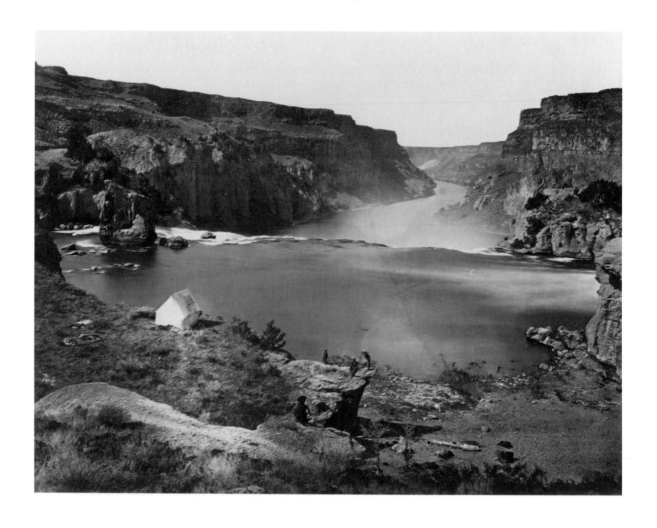

PLATE

9

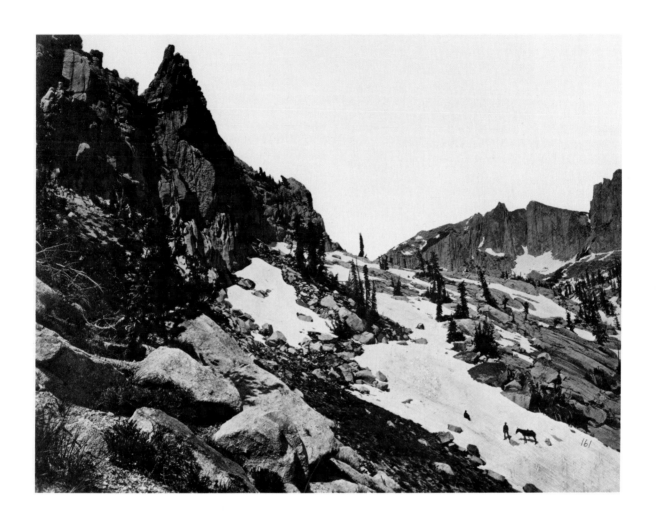

PLATE
10

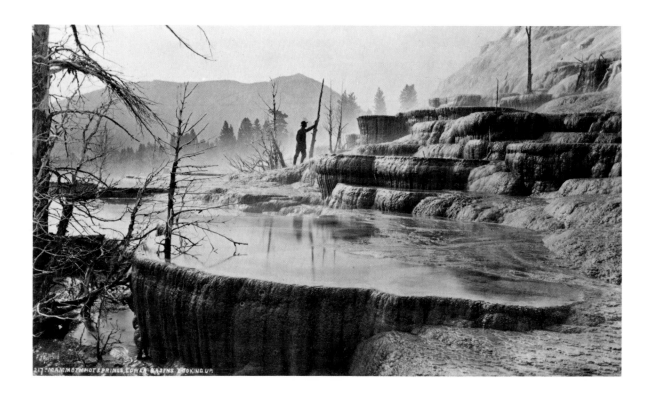

PLATE
11

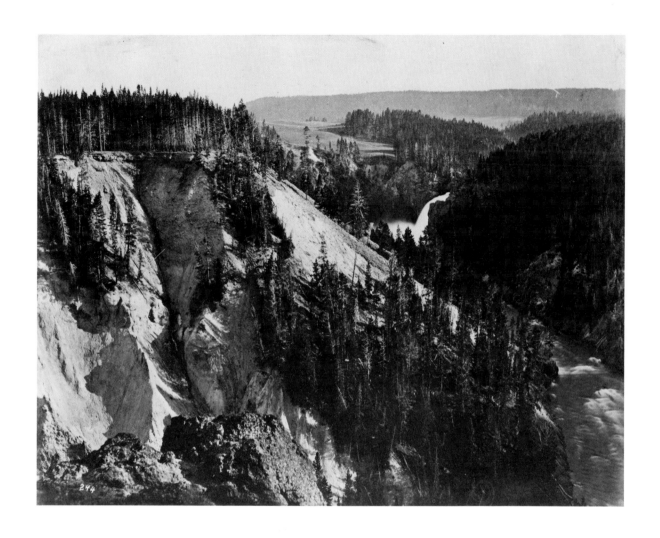

PLATE
12

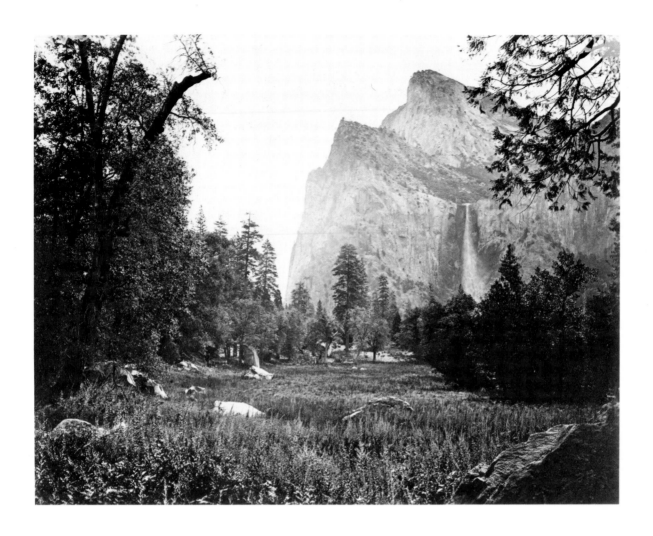

PLATE

13

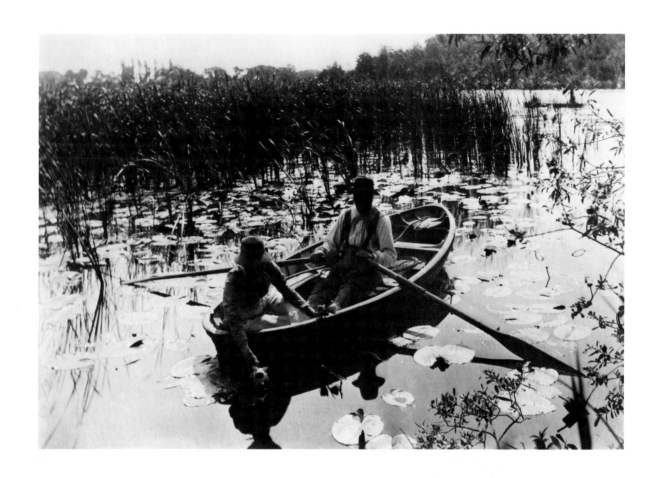

PLATE

14

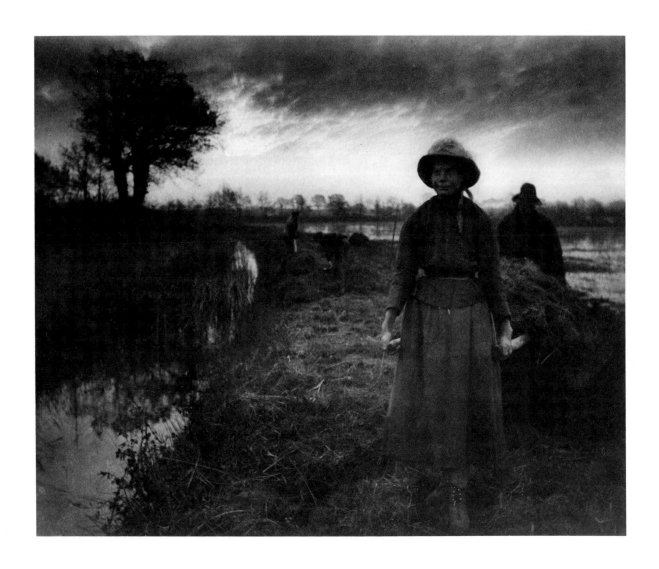

PLATE
15

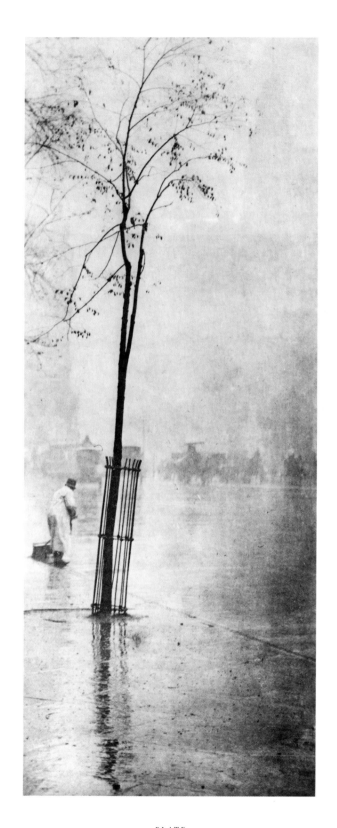

PLATE
16

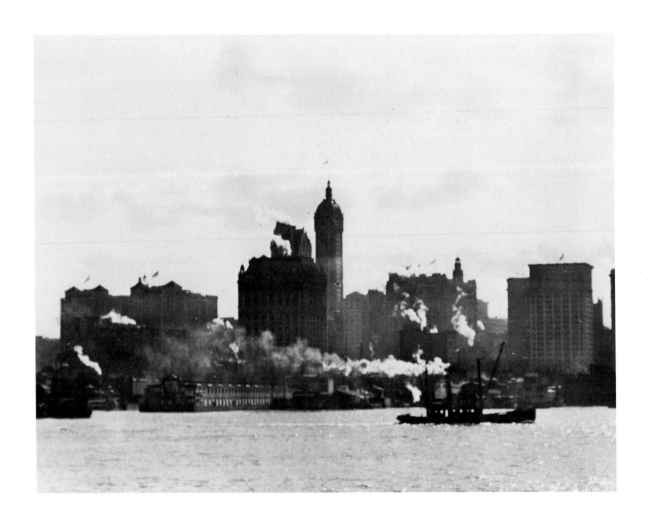

PLATE
17

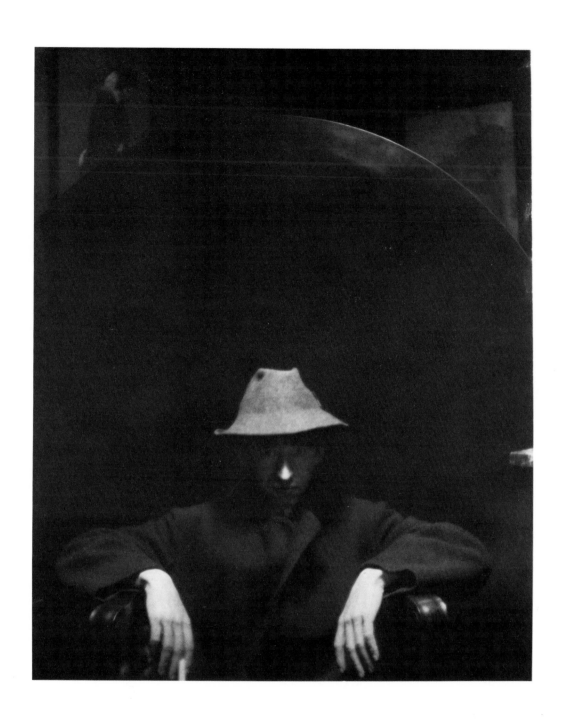

PLATE
18

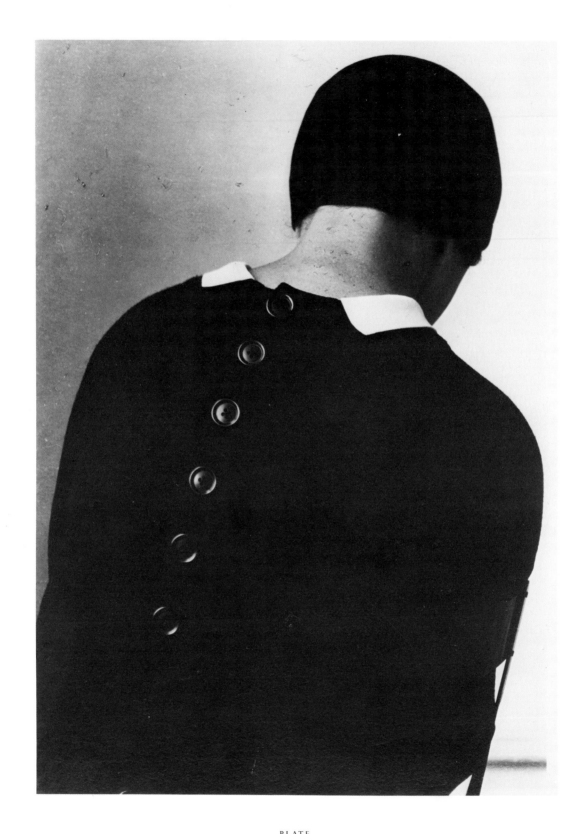

PLATE
19

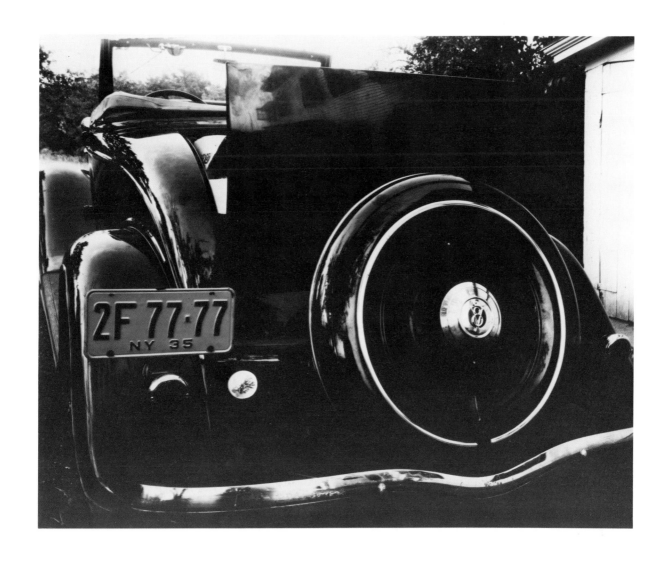

PLATE
20

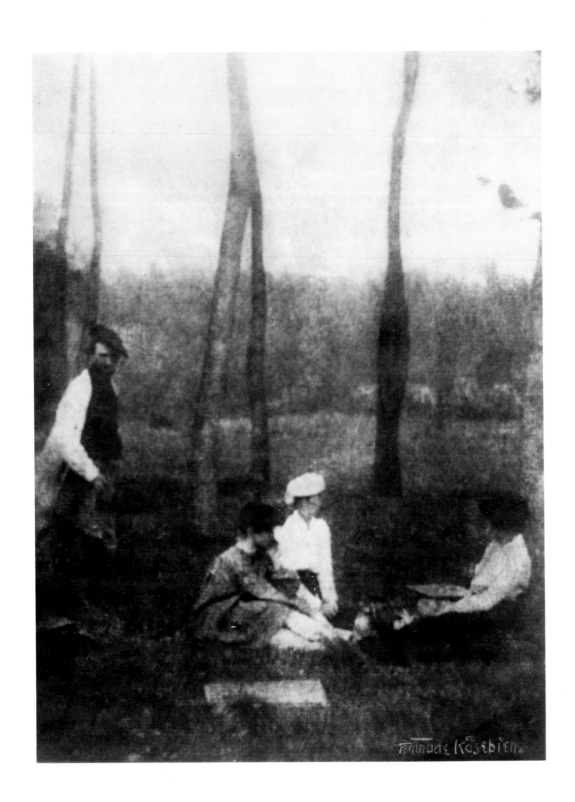

PLATE
21

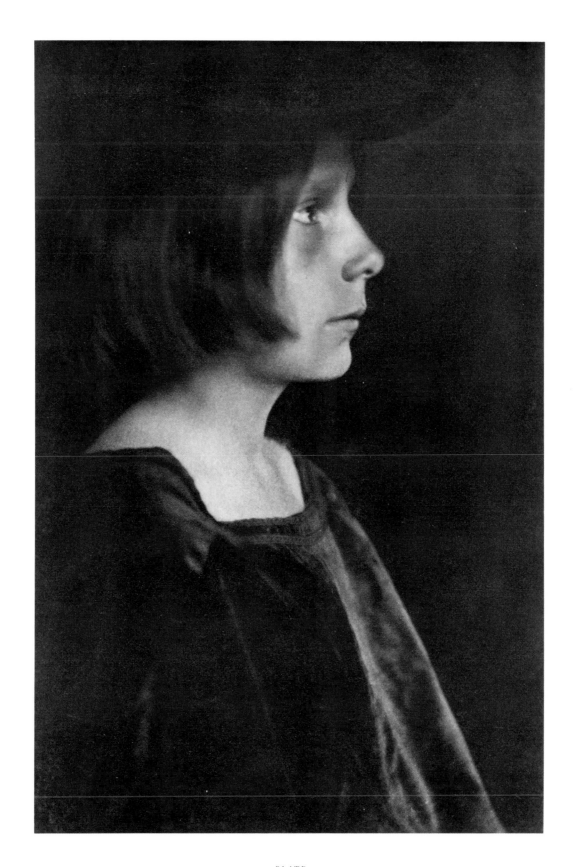

PLATE
22

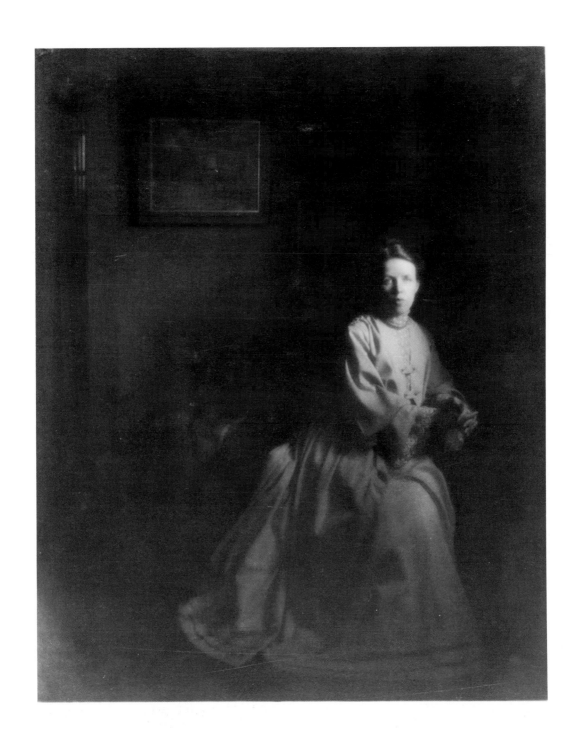

PLATE
23

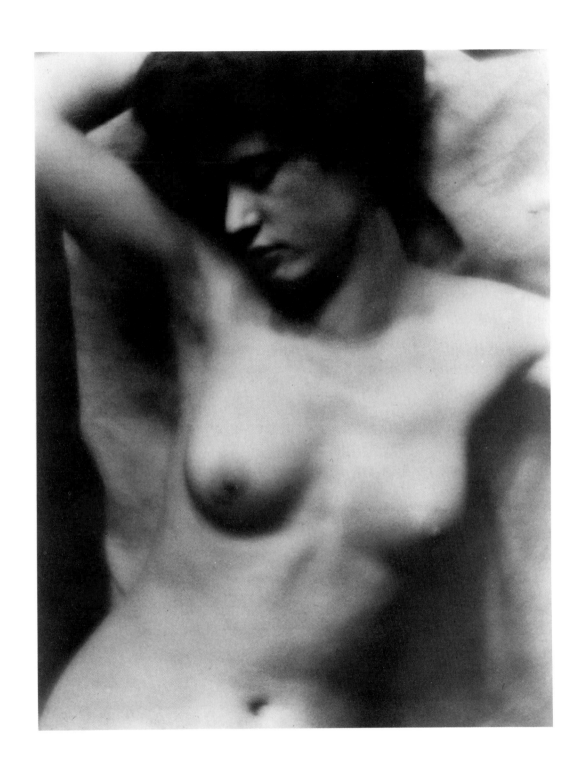

PLATE
24

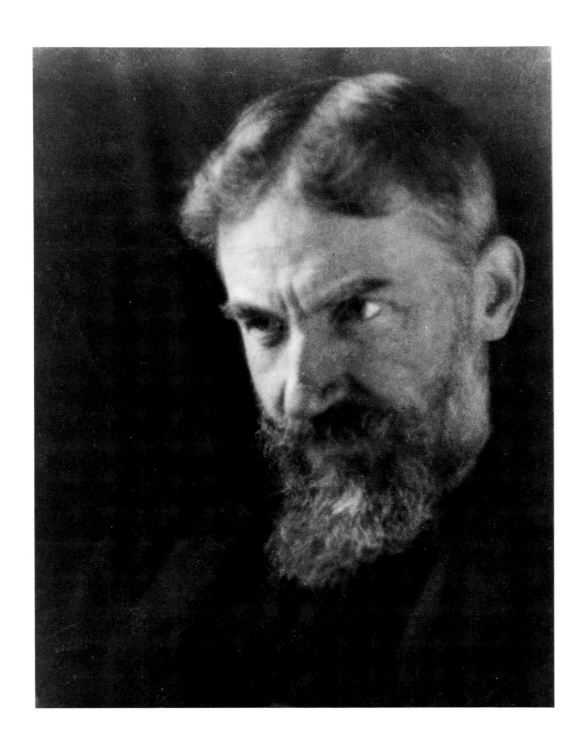

PLATE
25

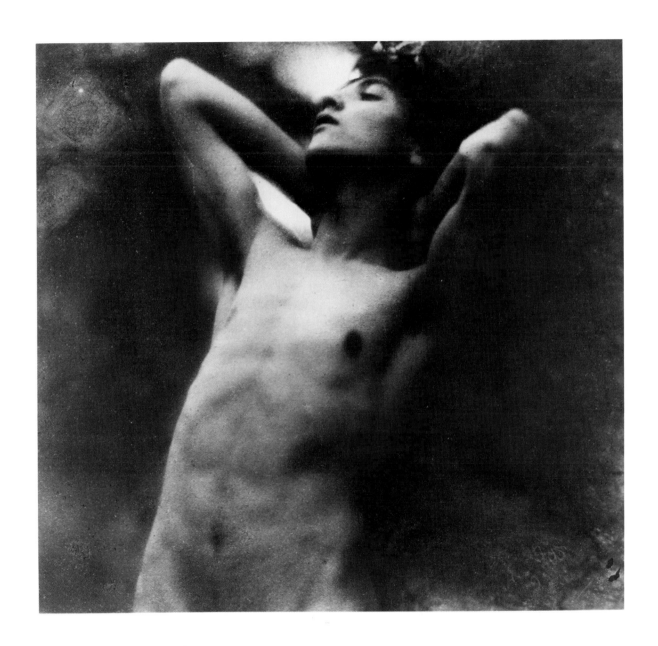

PLATE
26

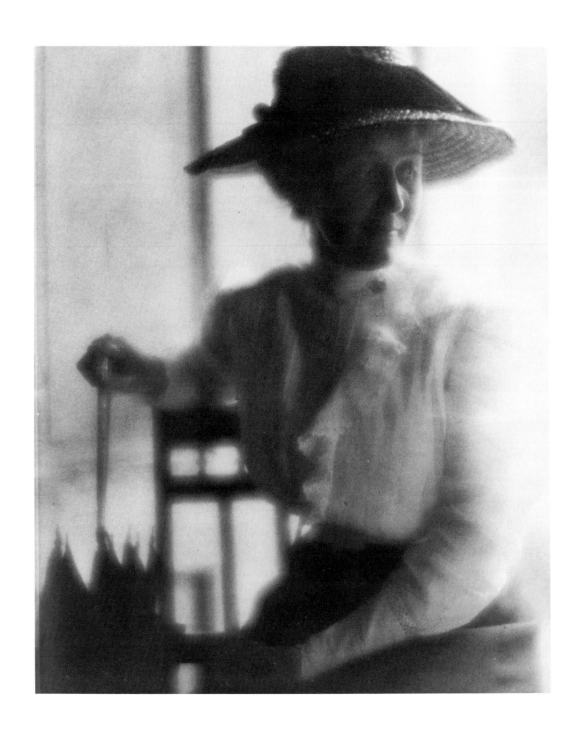

PLATE
27

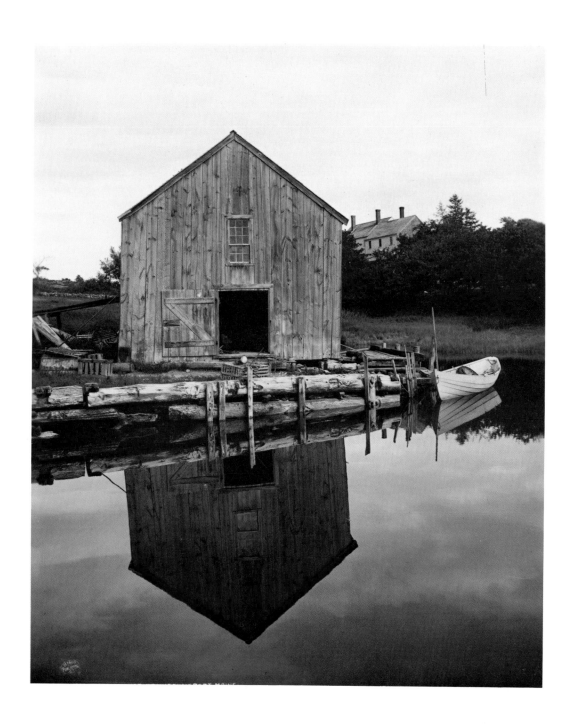

PLATE
28

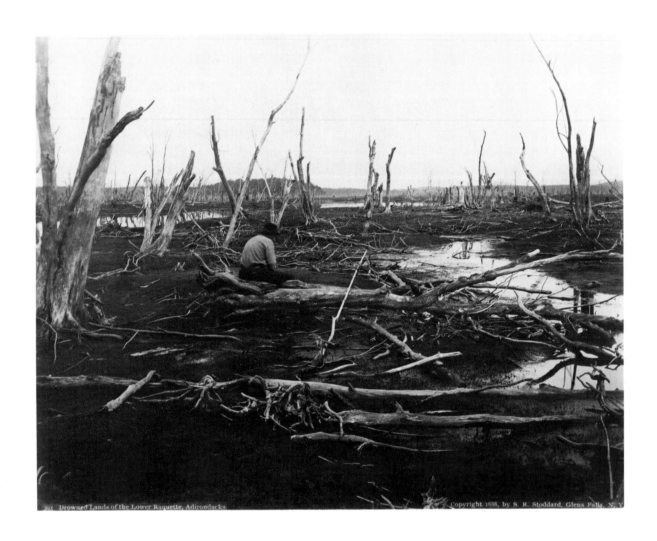

Drowned Lands of the Lower Raquette, Adirondacks Copyright 1888, by S. R. Stoddard, Glens Falls, N. Y.

PLATE
29

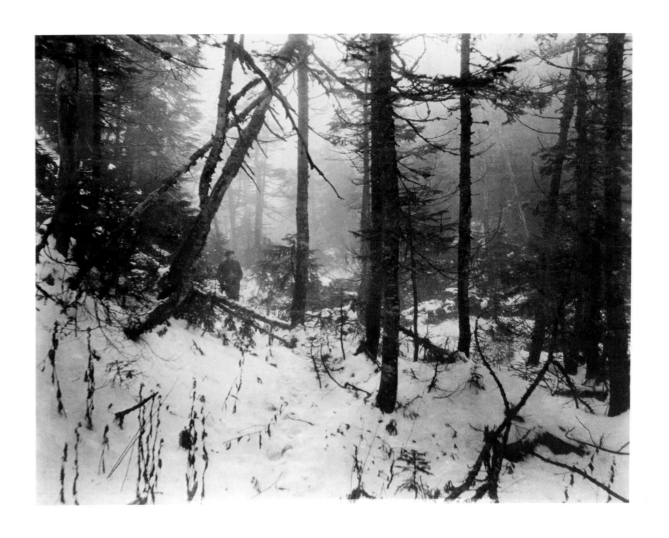

PLATE
30

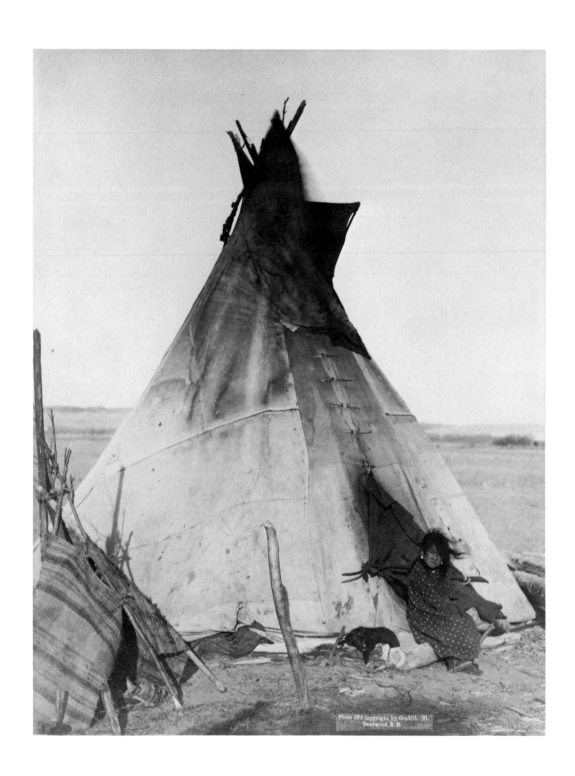

PLATE

31

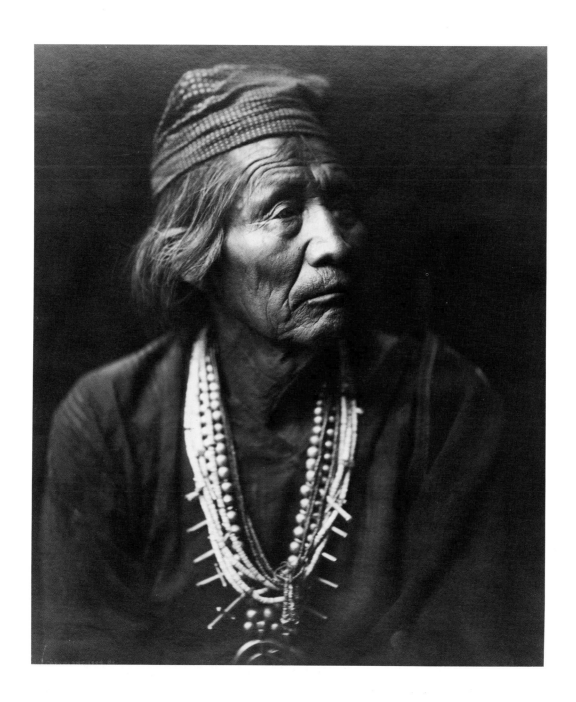

PLATE
32

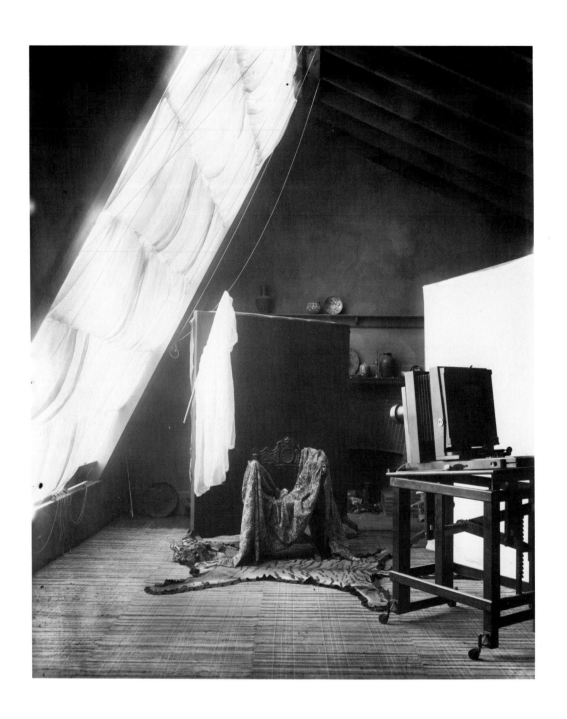

PLATE
33

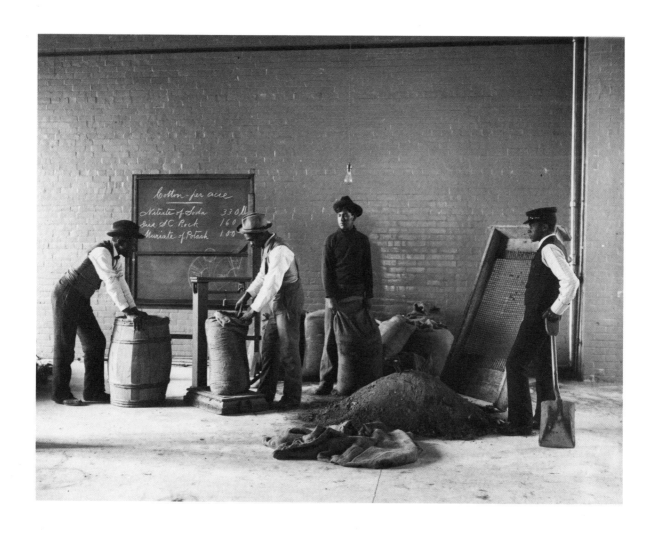

PLATE
34

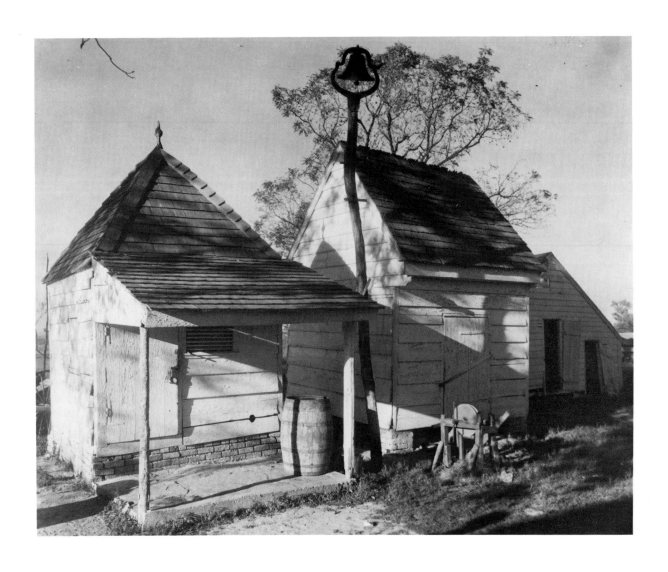

PLATE
35

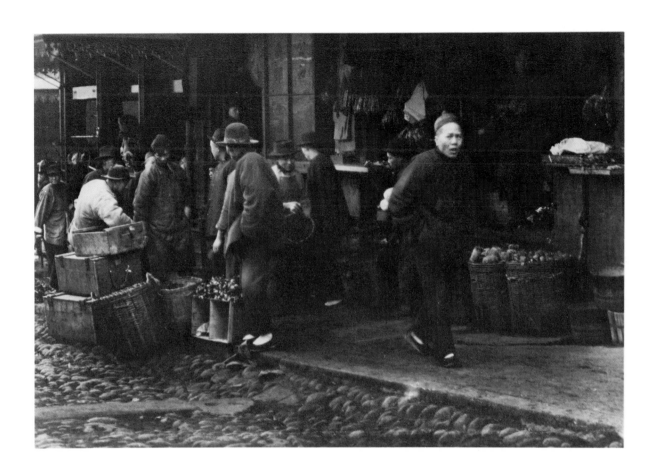

PLATE
36

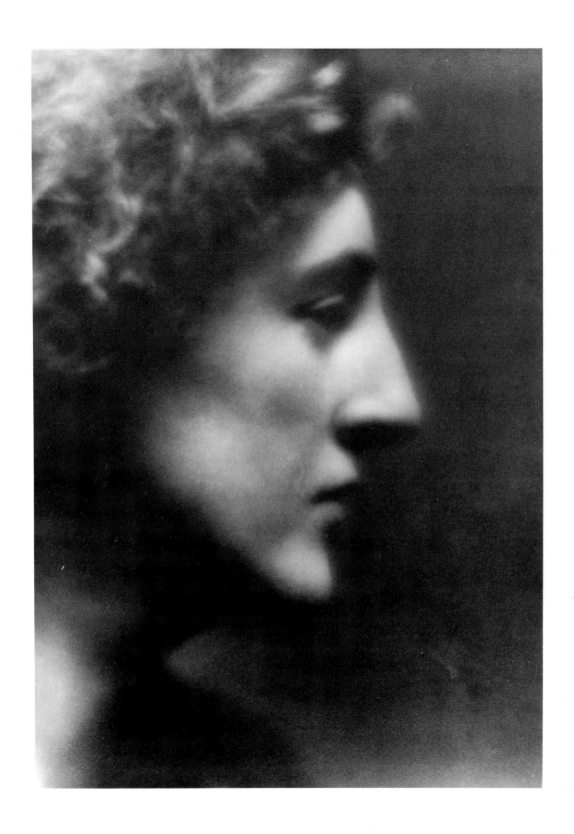

PLATE
37

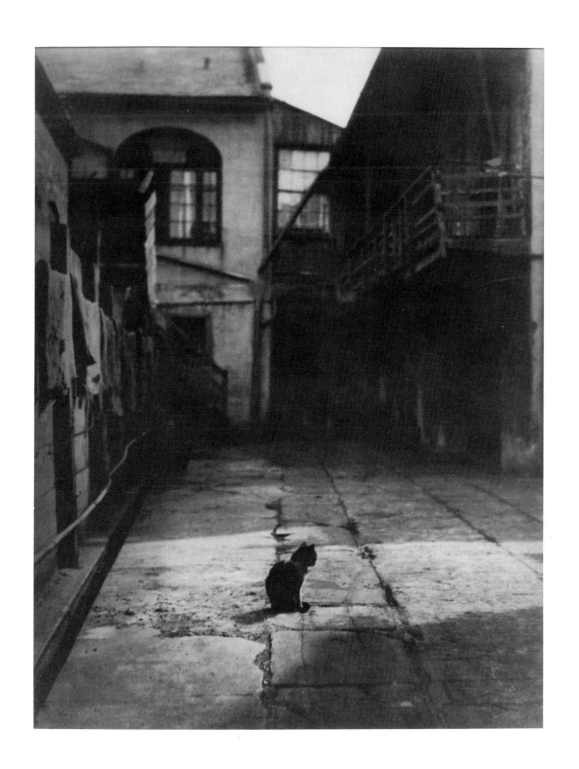

PLATE
38

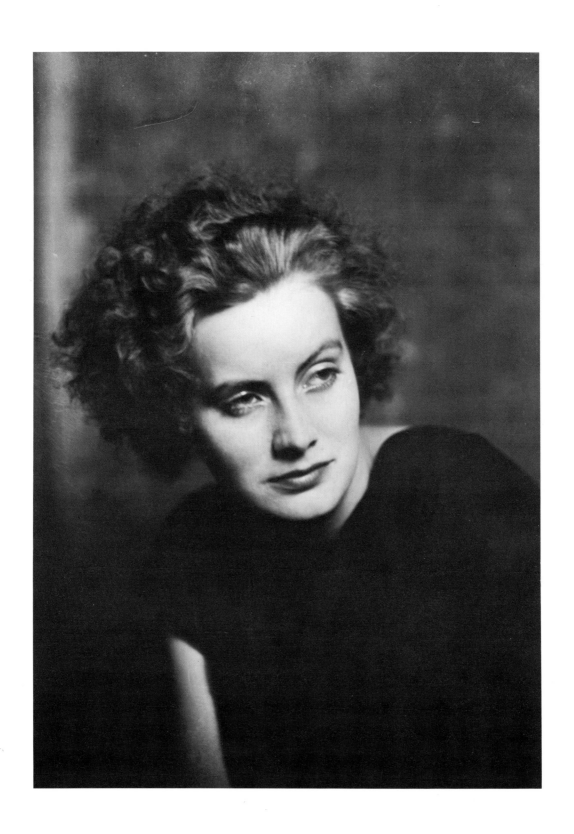

PLATE
39

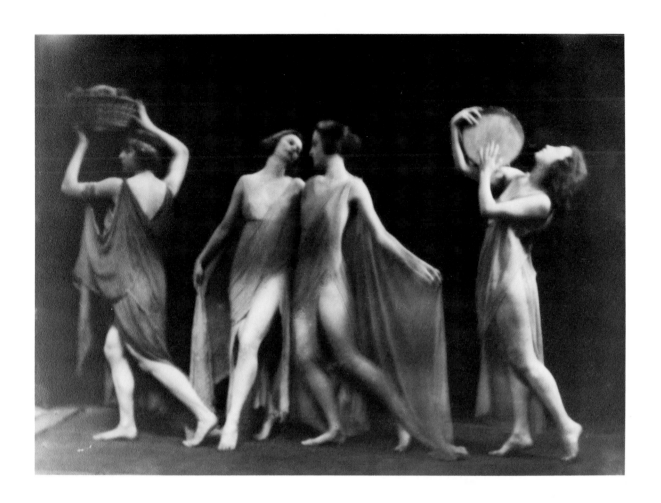

PLATE
40

PLATE
41

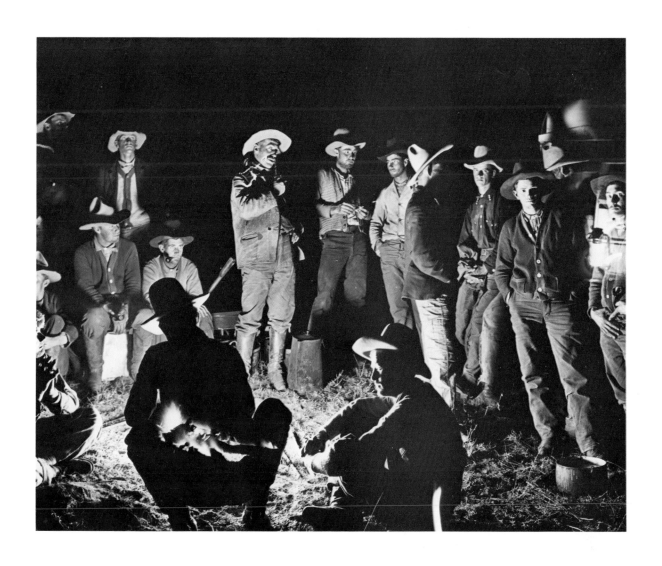

PLATE
42

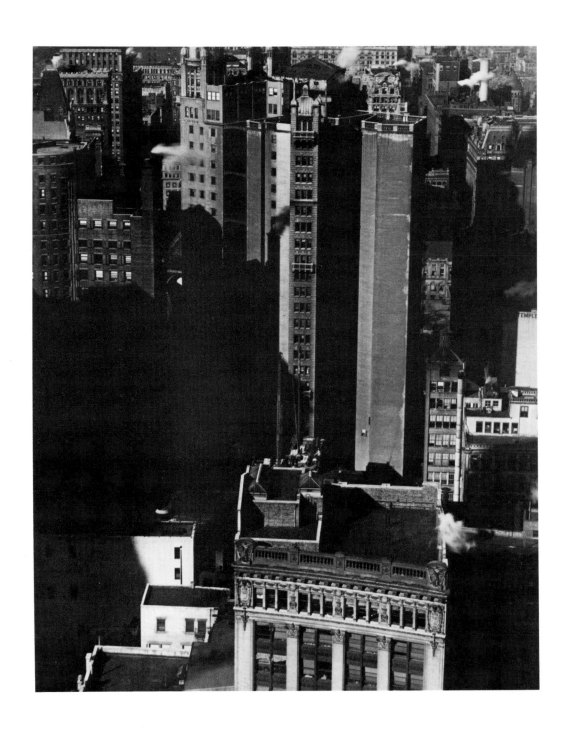

PLATE
43

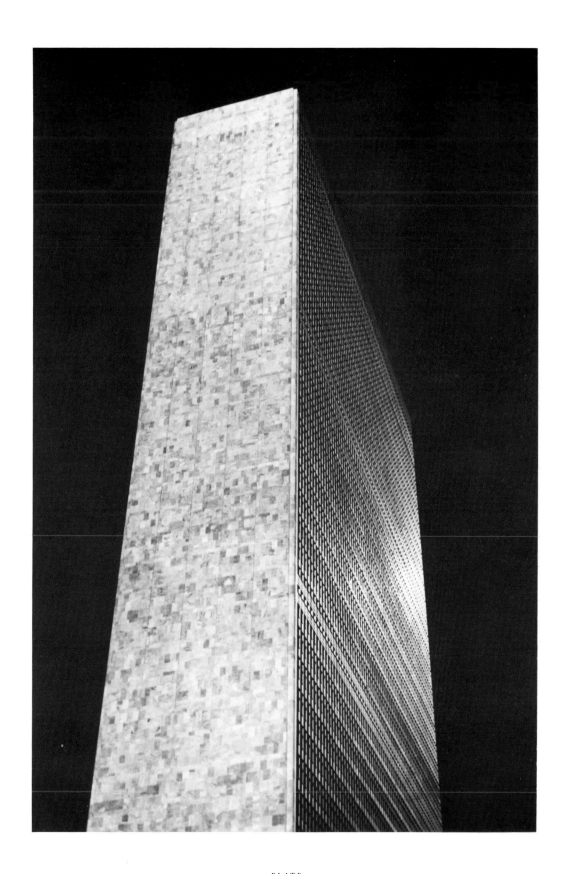

PLATE

44

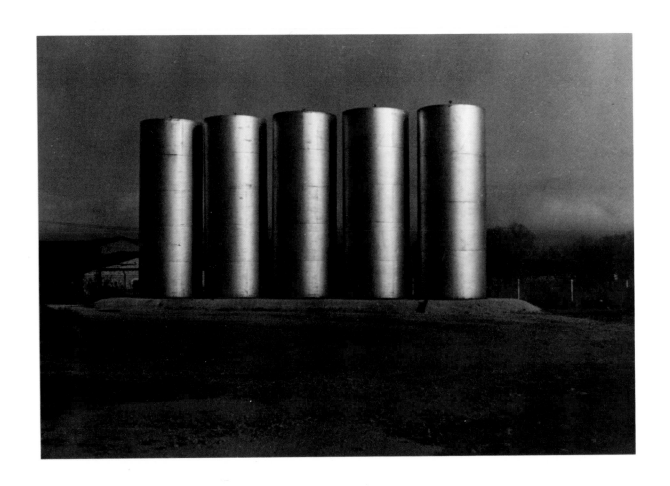

PLATE
45

PLATE
46

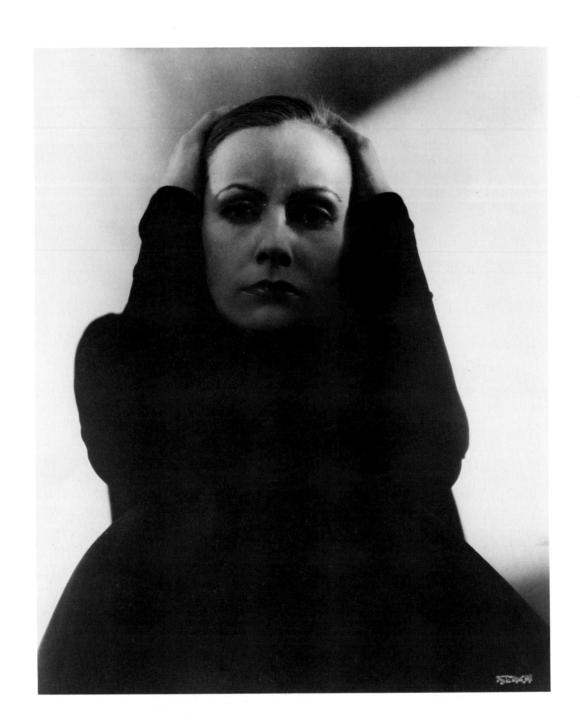

PLATE
47

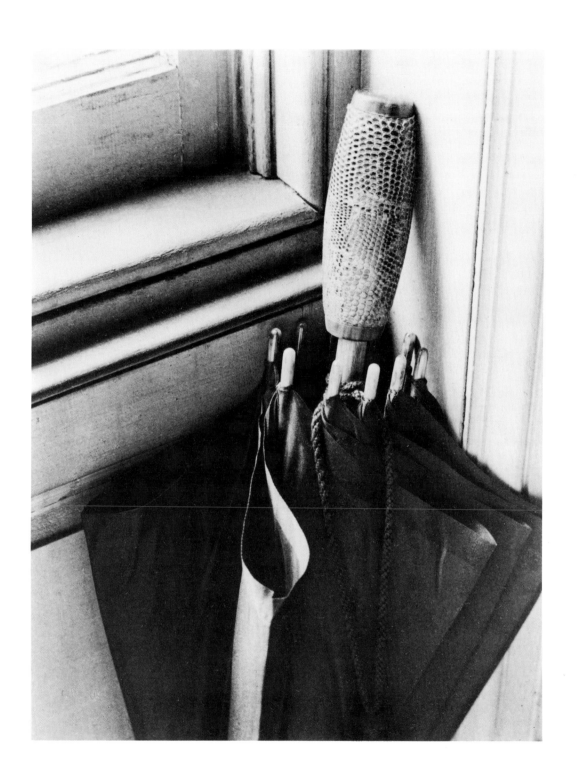

PLATE
48

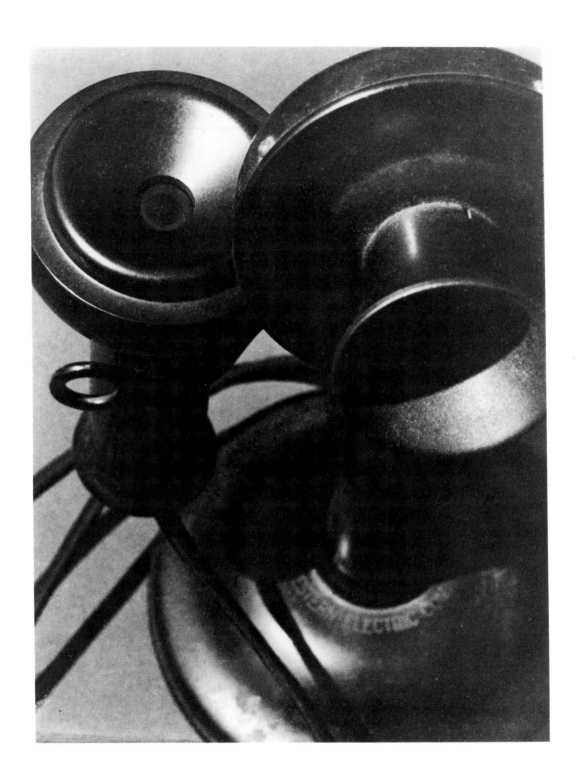

PLATE
49

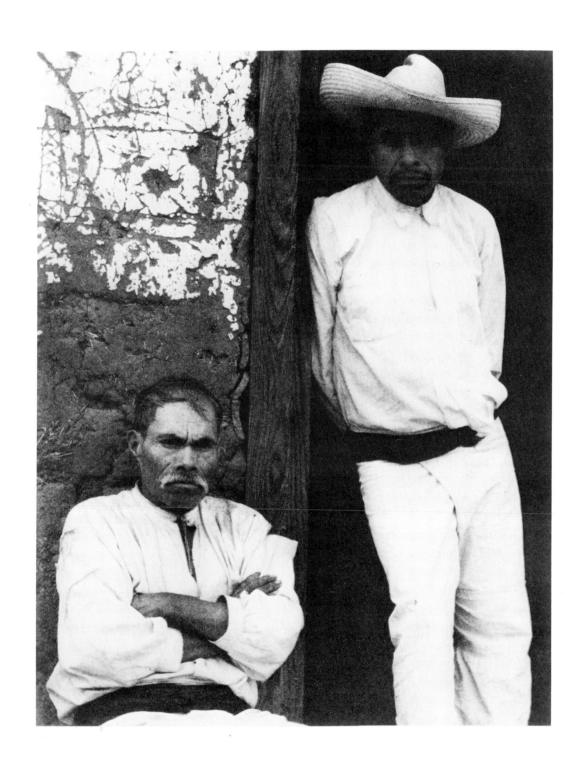

PLATE
50

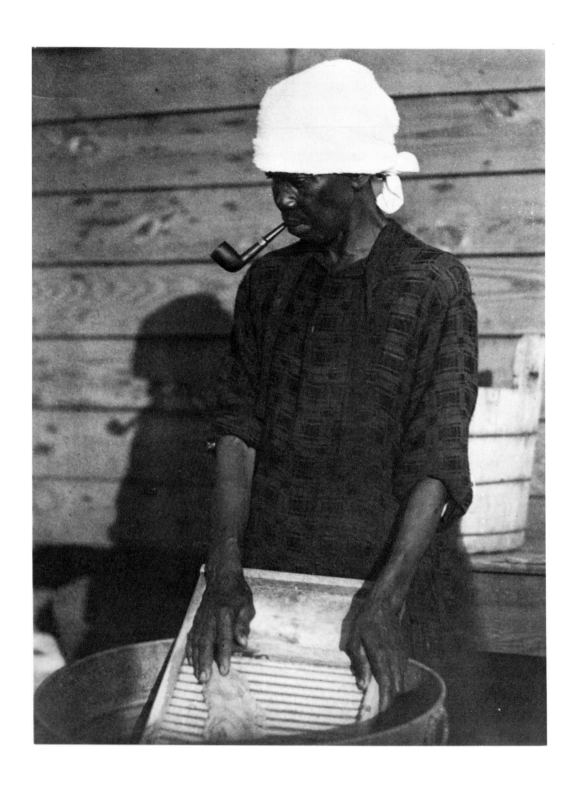

PLATE
51

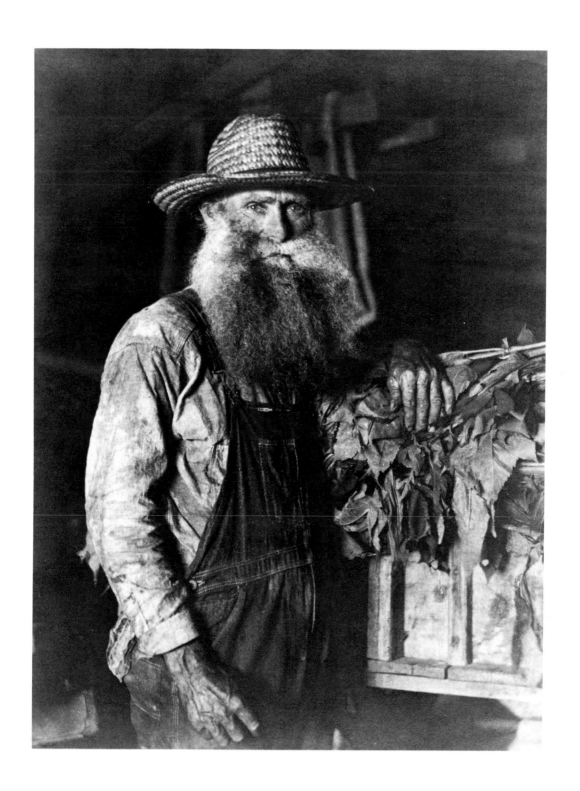

PLATE
52

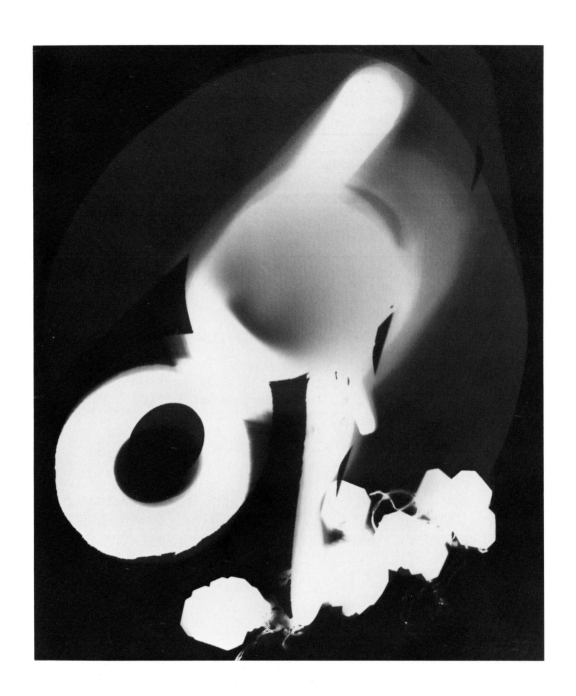

PLATE

53

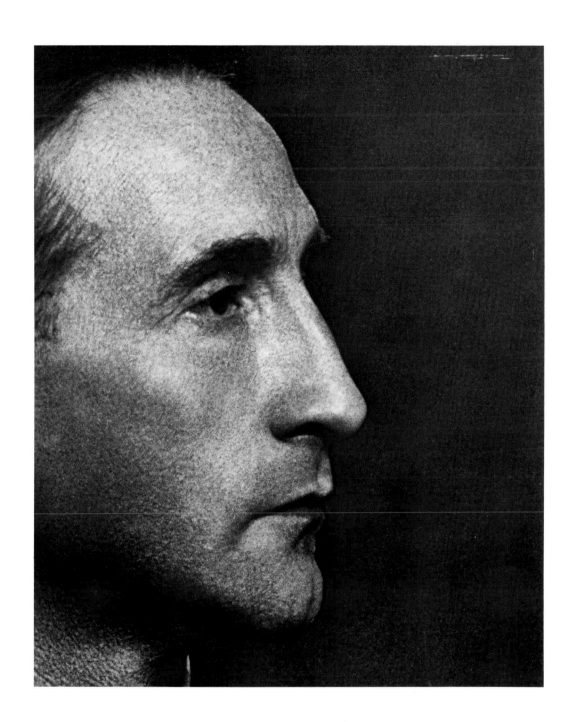

PLATE
54

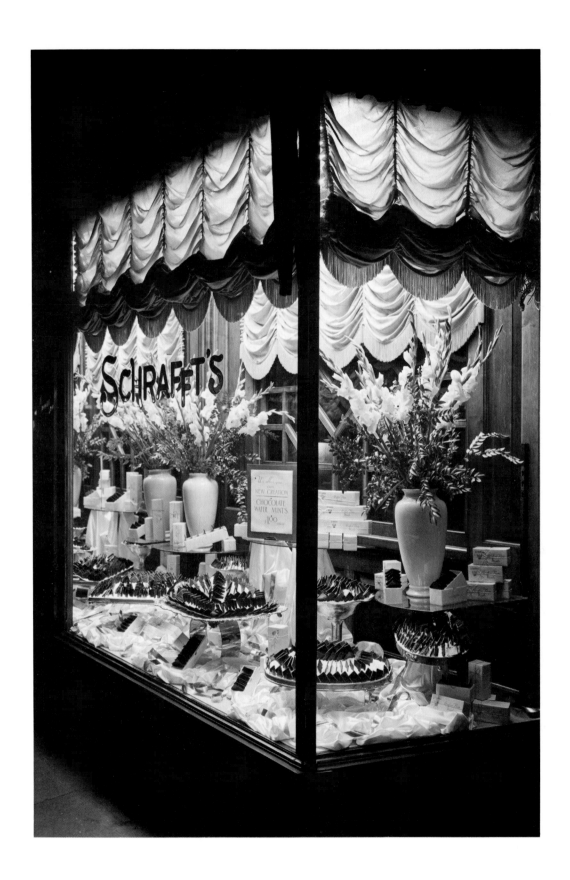

PLATE
55

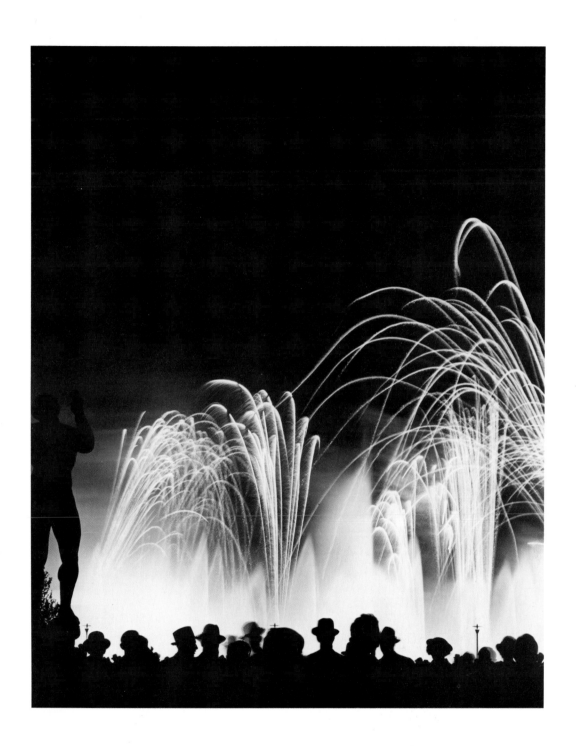

PLATE
56

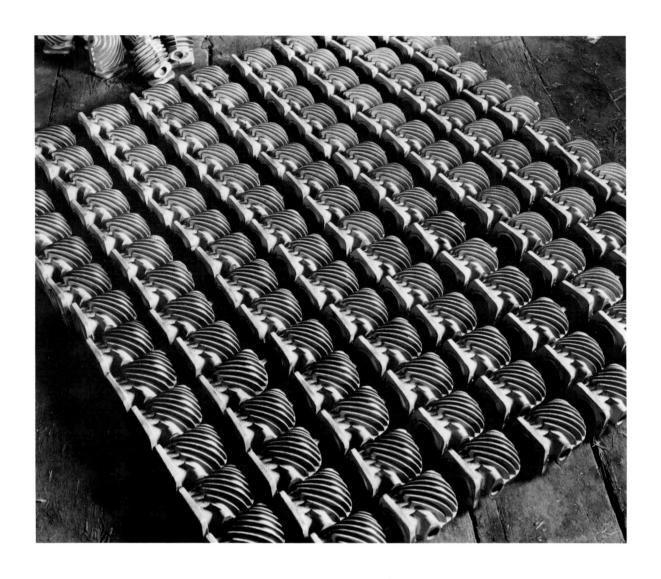

PLATE
57

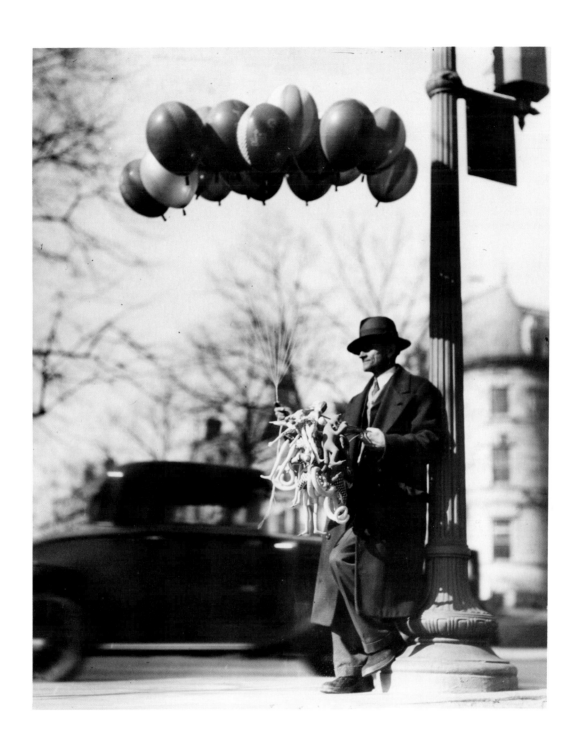

PLATE
58

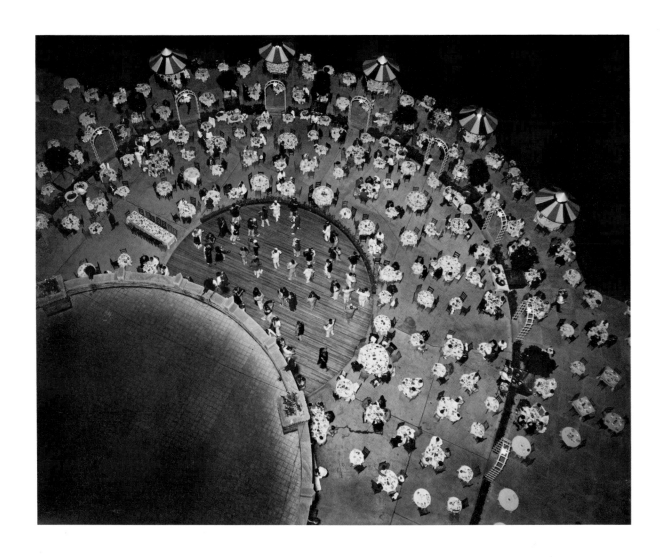

PLATE
59

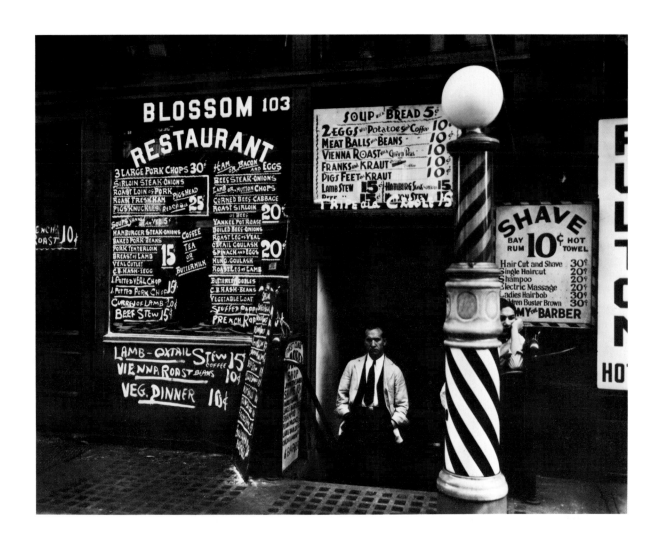

PLATE
60

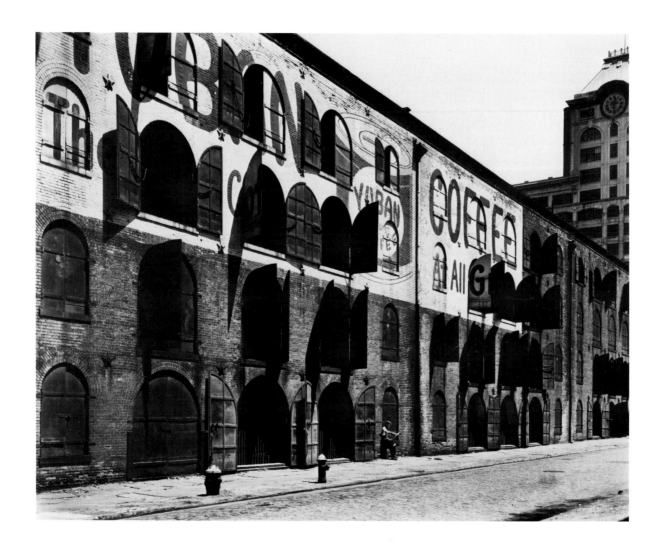

PLATE
61

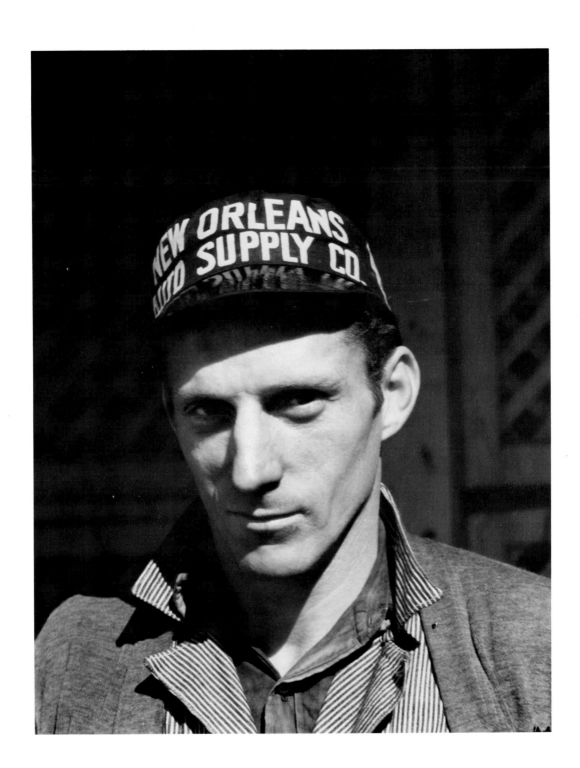

PLATE

62

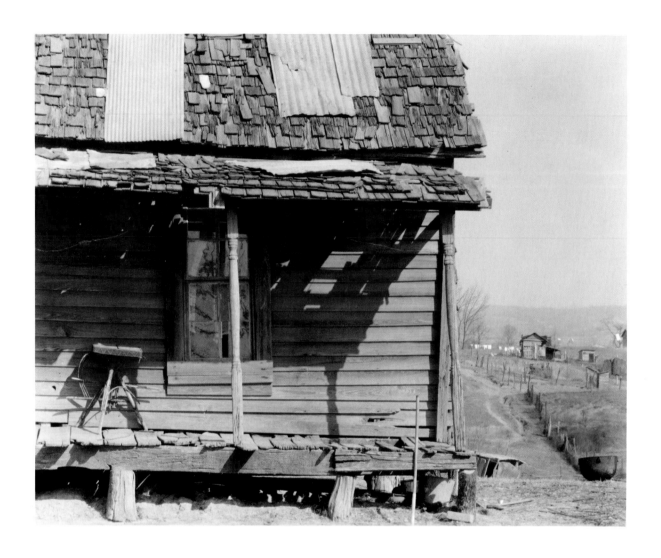

PLATE
63

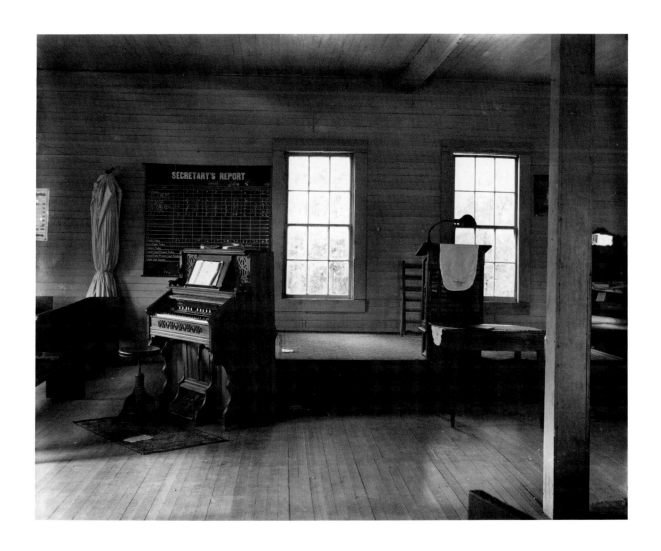

PLATE
64

PLATE
65

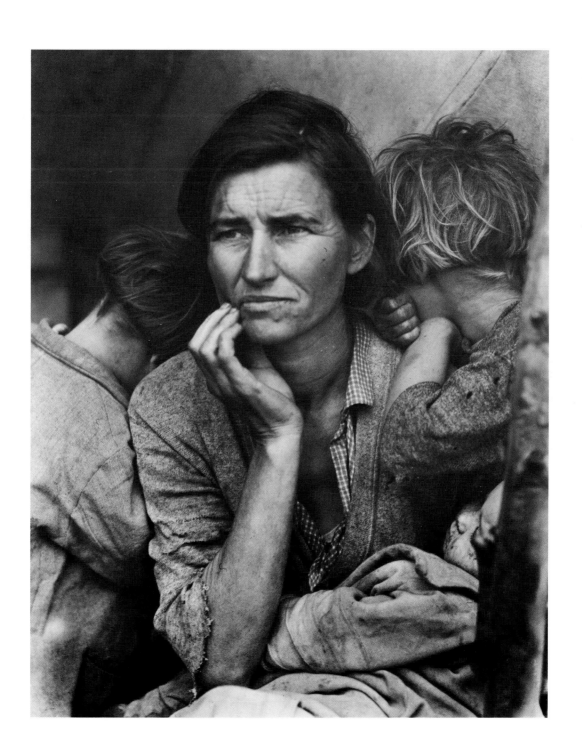

PLATE
66

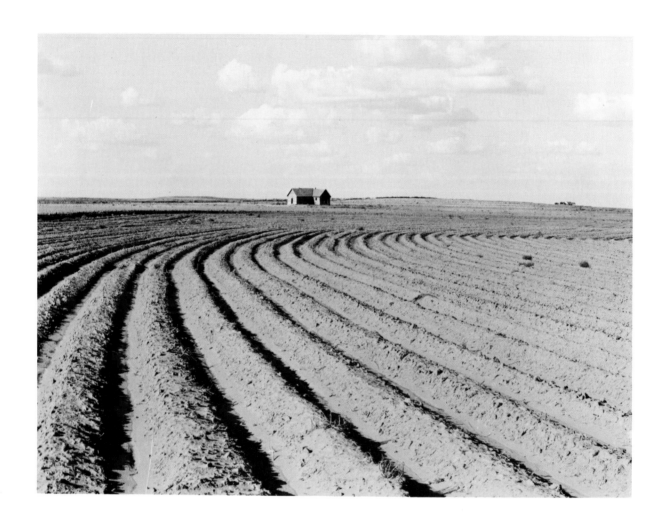

PLATE
67

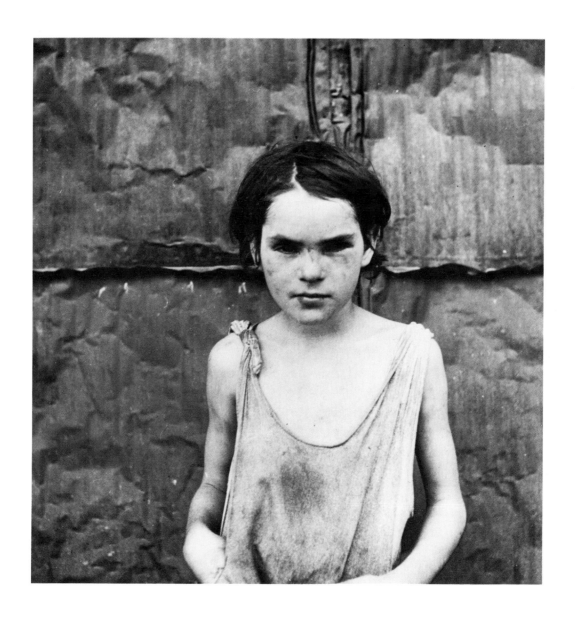

PLATE
68

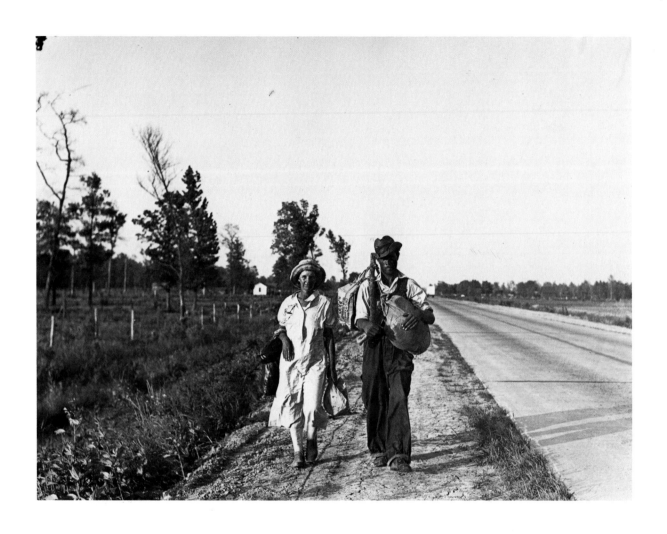

PLATE
69

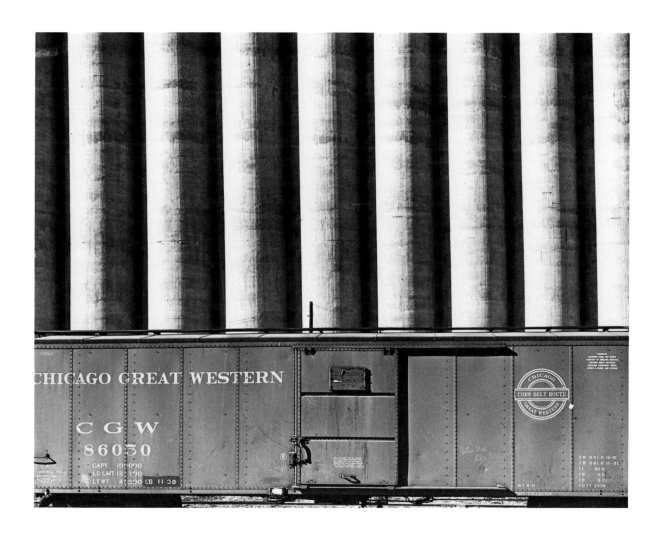

PLATE
70

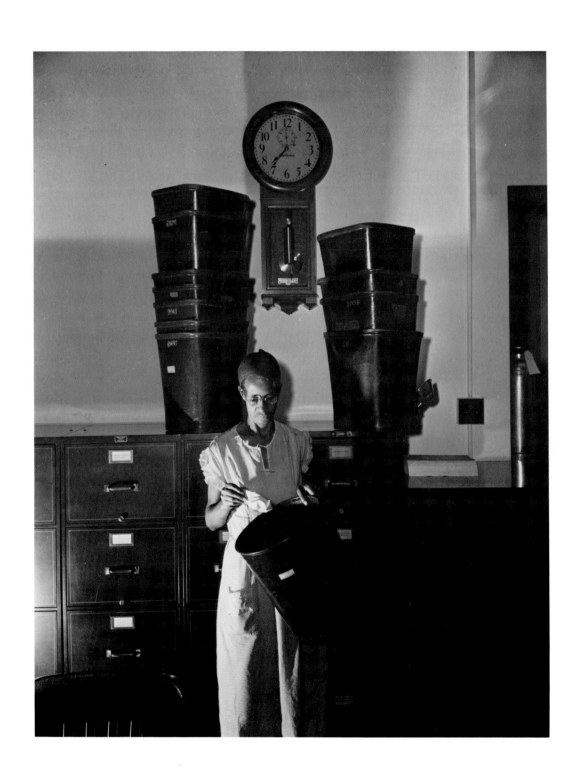

PLATE
71

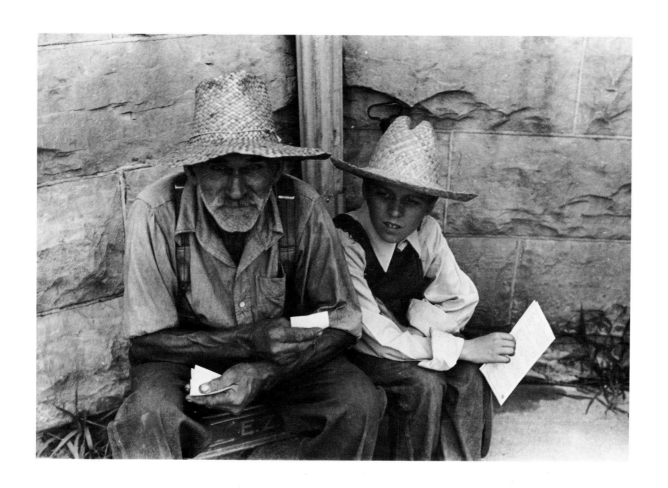

PLATE

72

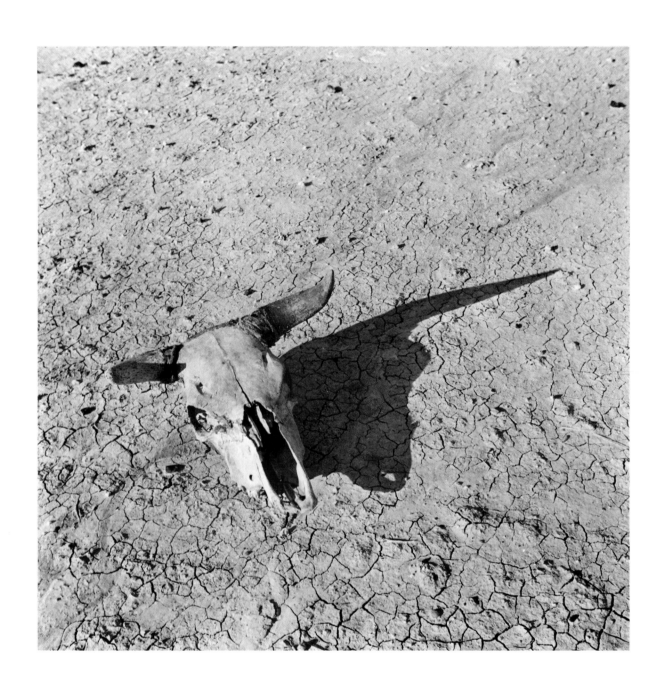

PLATE
73

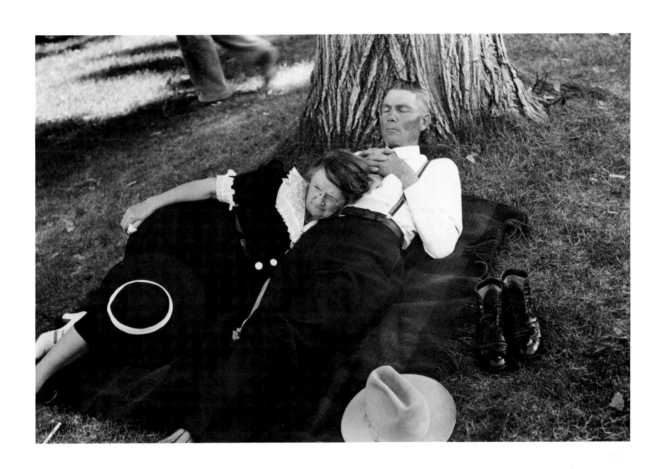

PLATE
74

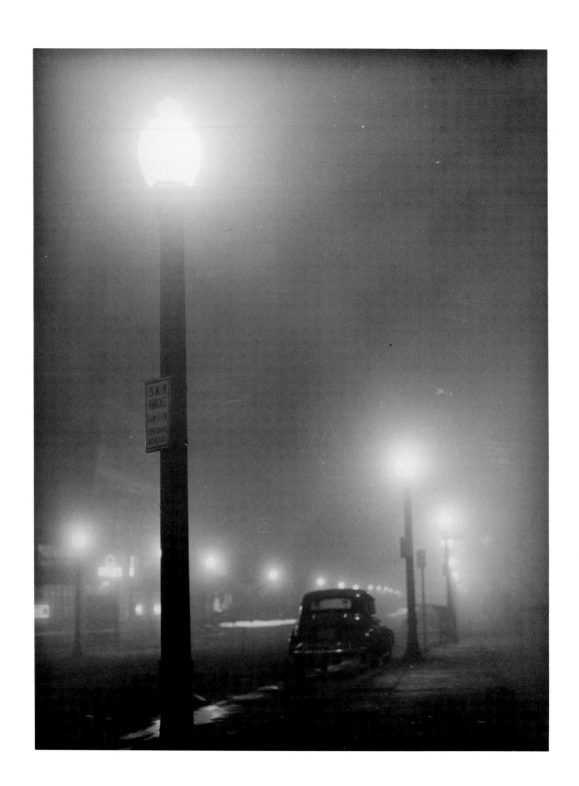

PLATE
75

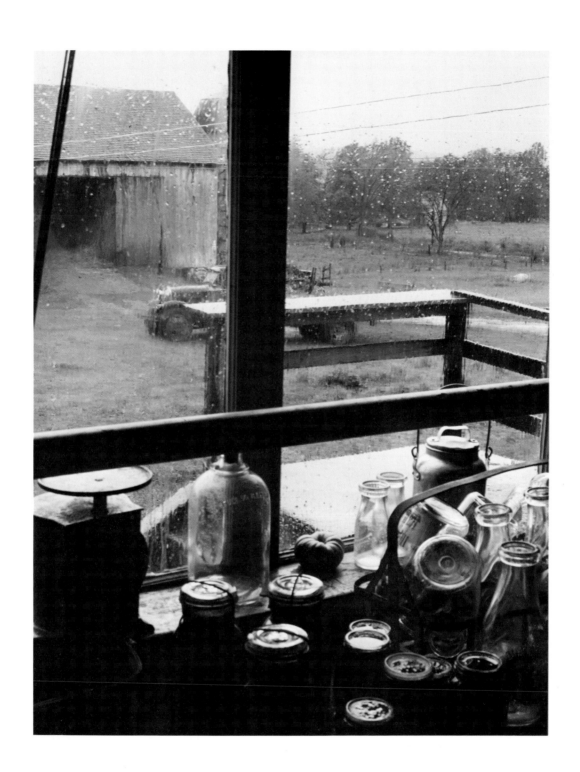

PLATE
76

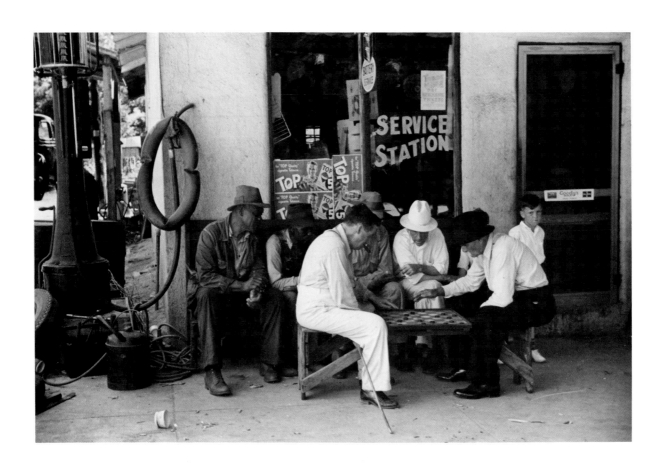

PLATE
77

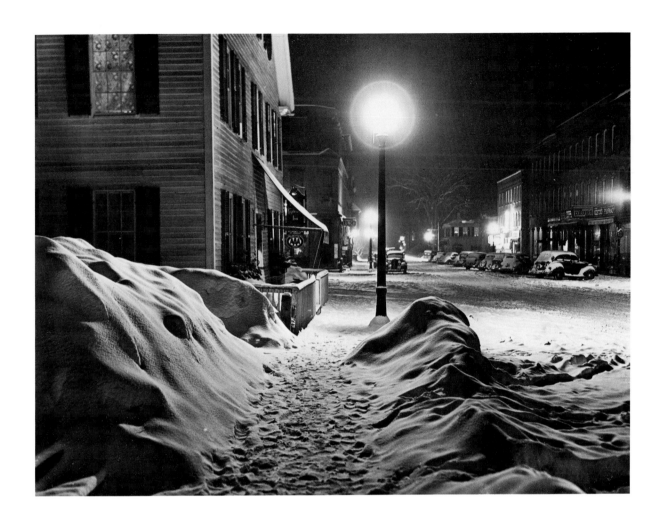

PLATE
78

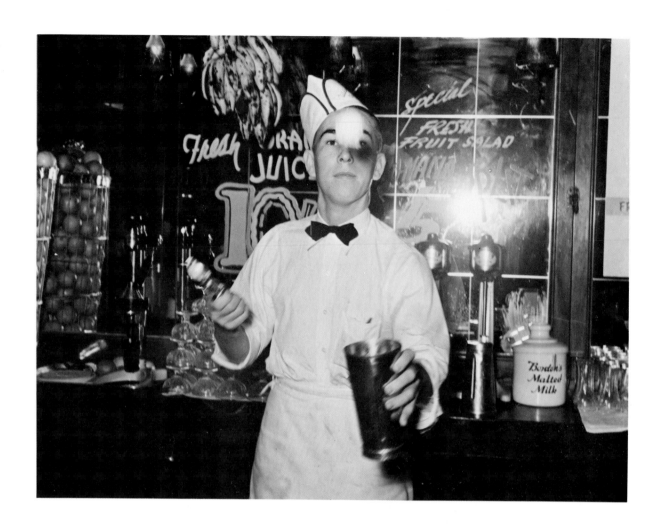

PLATE
79

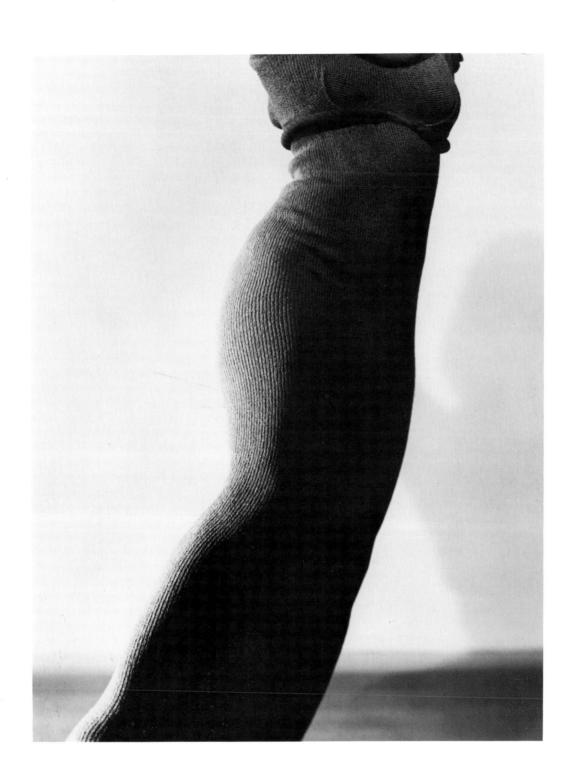

PLATE
80

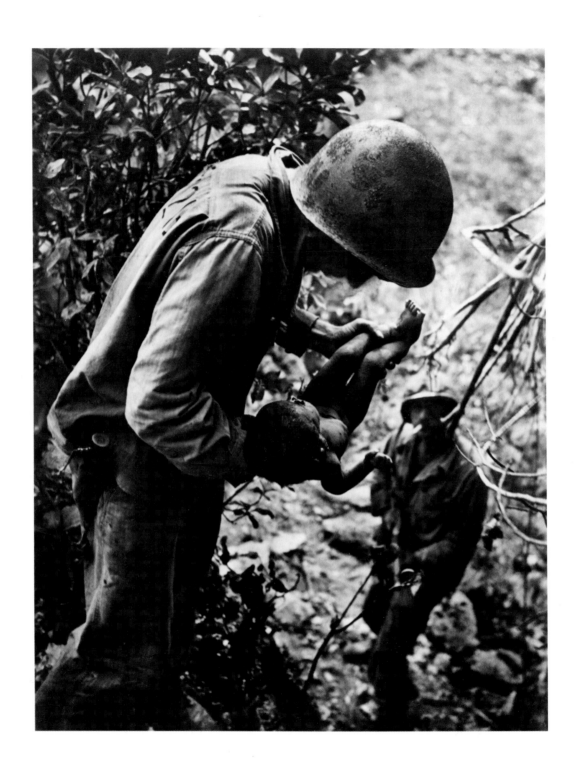

PLATE
81

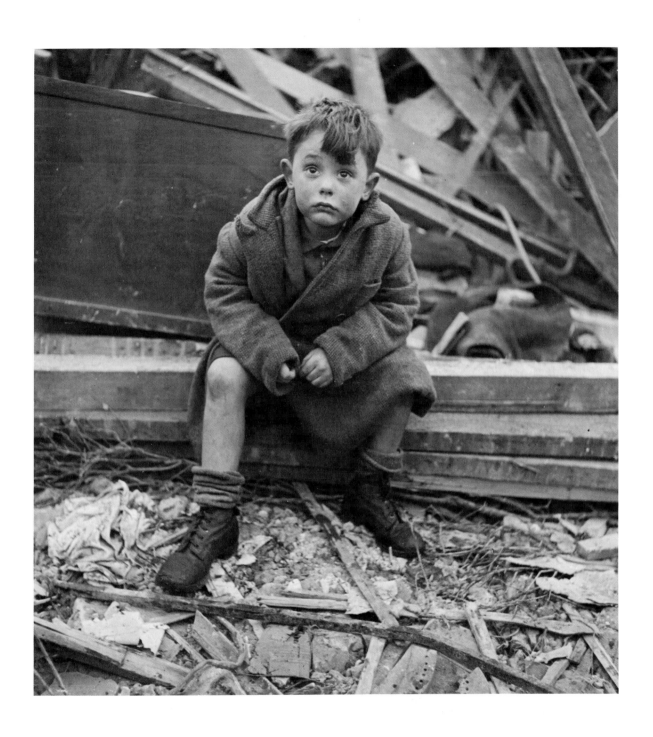

PLATE
82

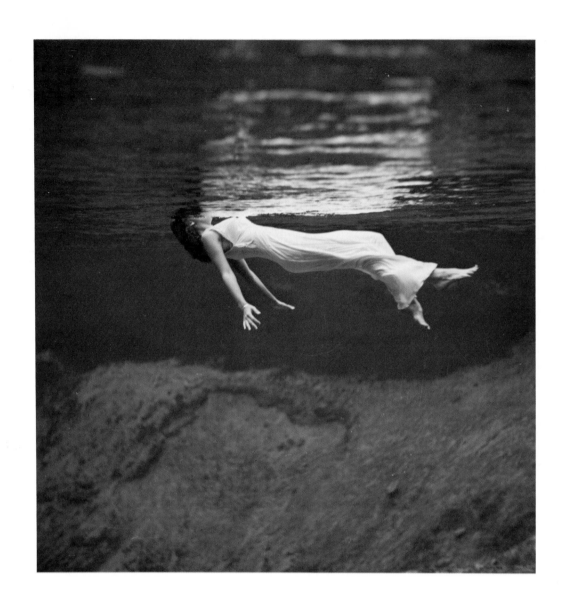

PLATE
83

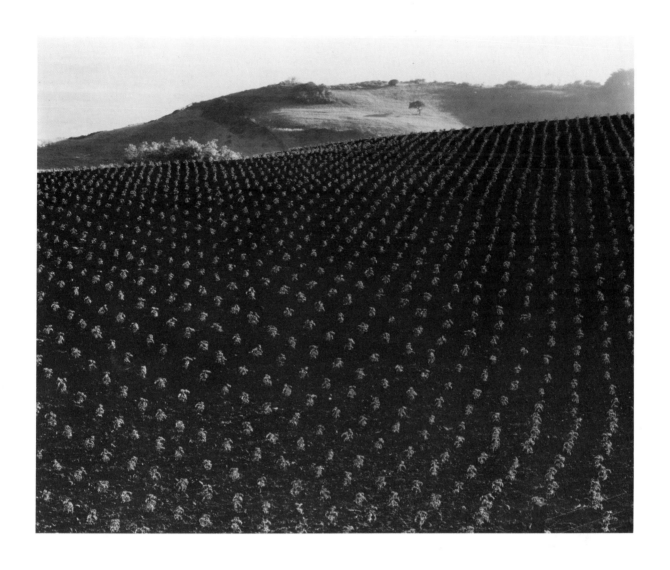

PLATE
84

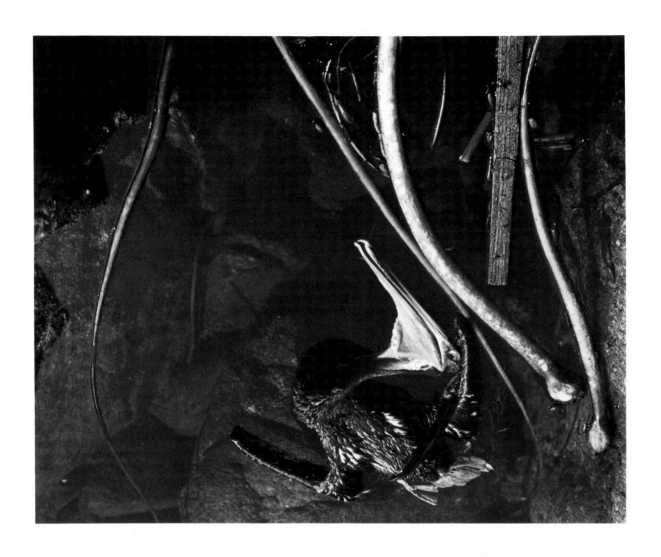

PLATE
85

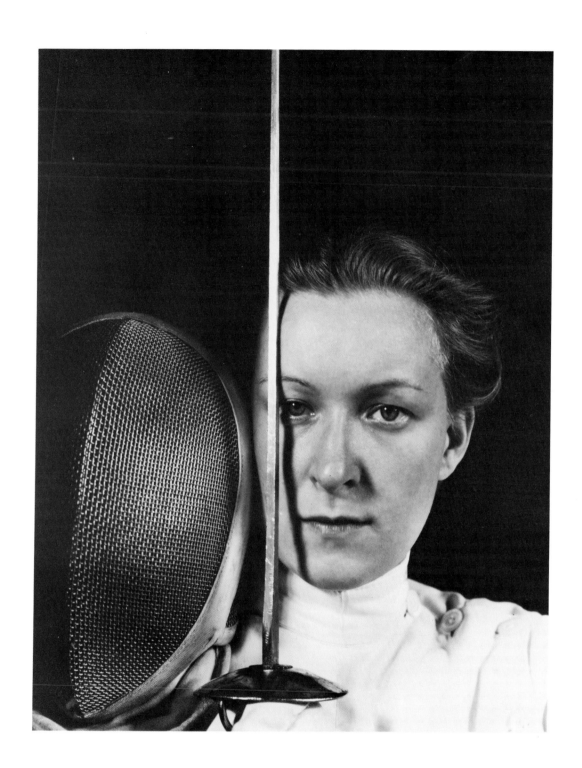

PLATE
86

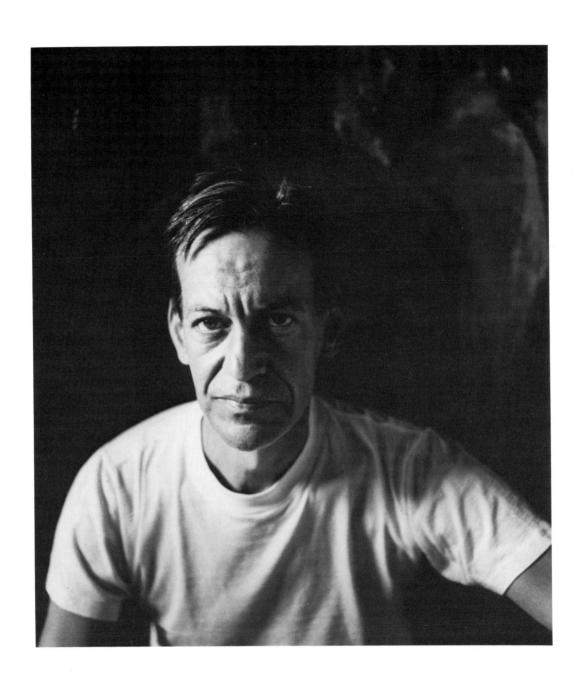

PLATE
87

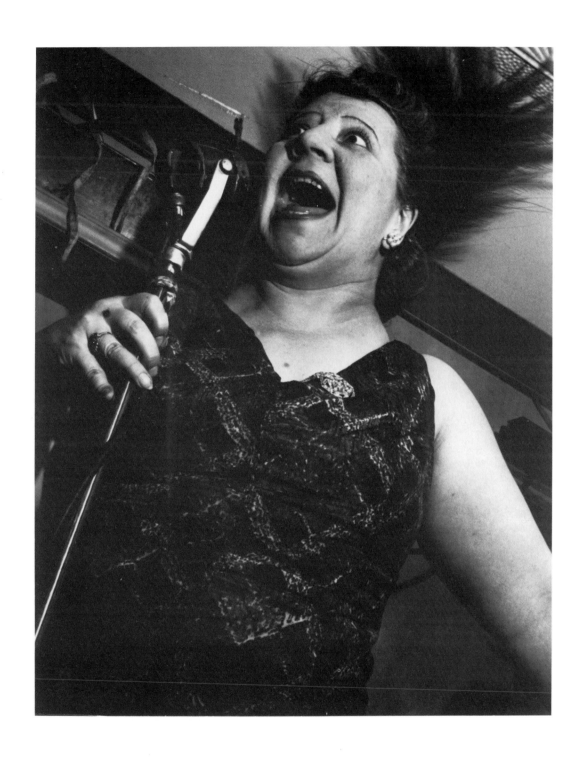

PLATE
88

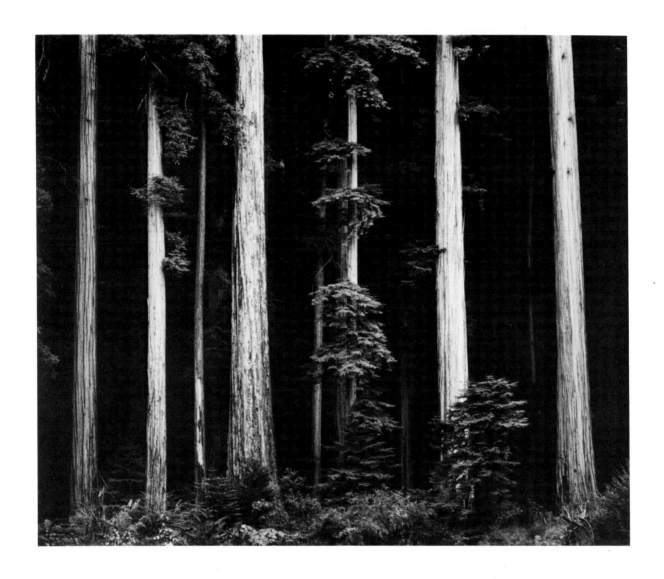

PLATE
89

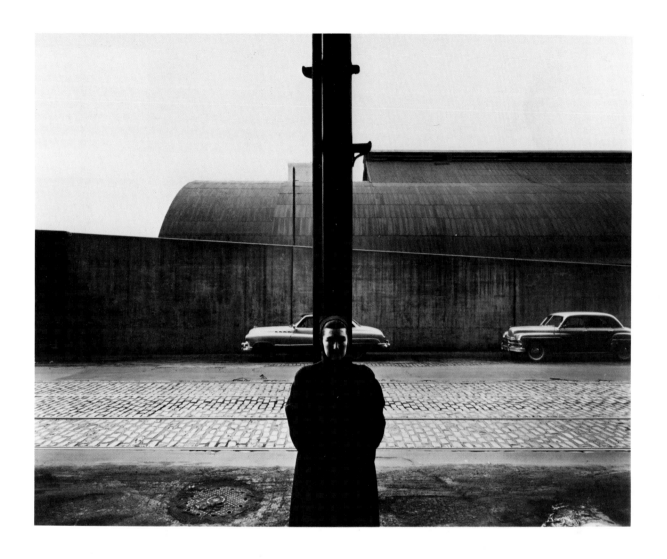

PLATE
90

PLATE
91

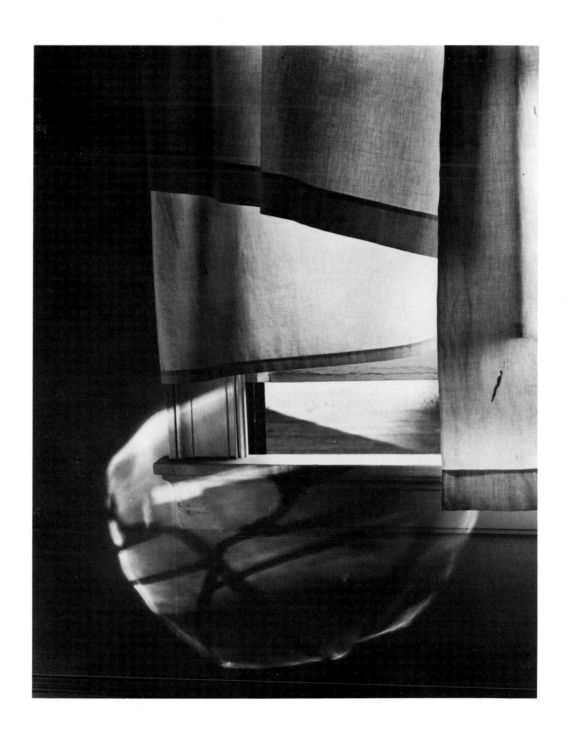

PLATE
92

PLATE
93

PLATE
94

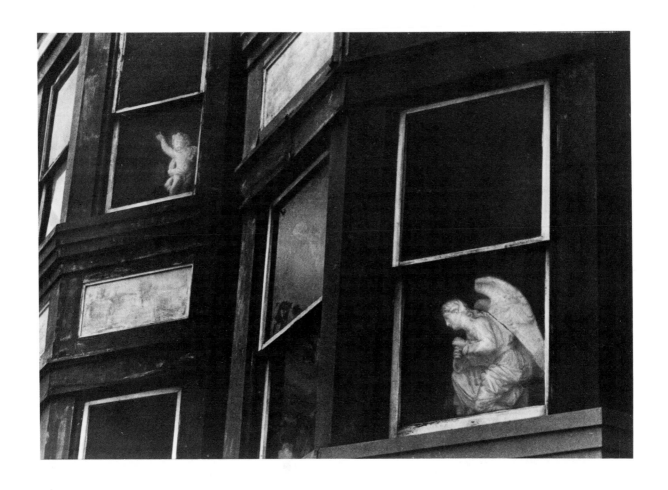

PLATE

95

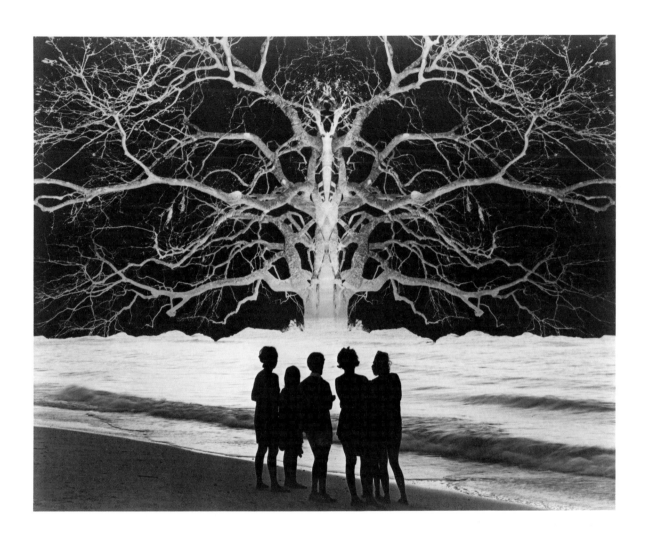

PLATE

96

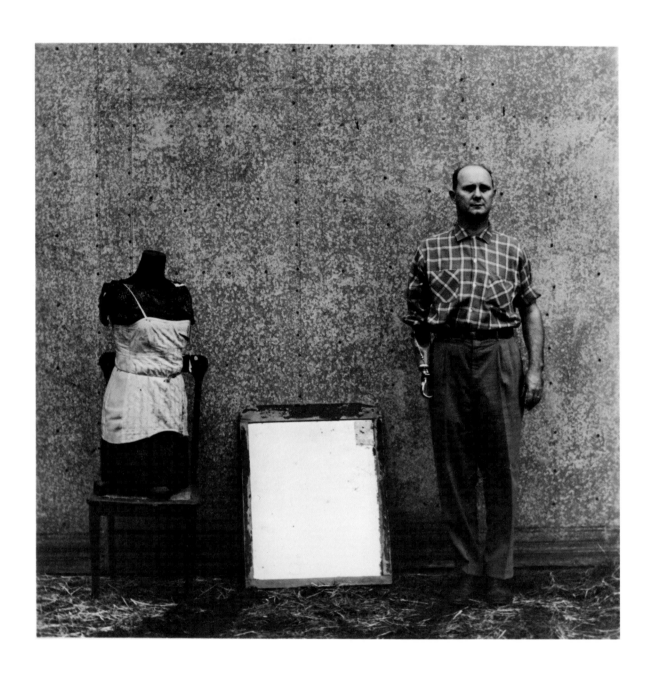

PLATE

97

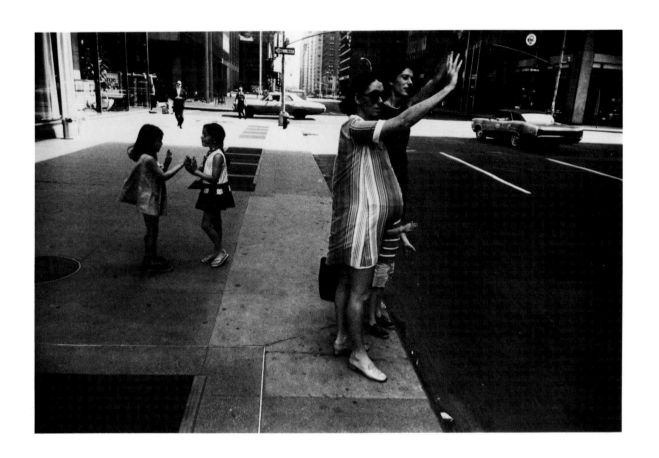

PLATE
98

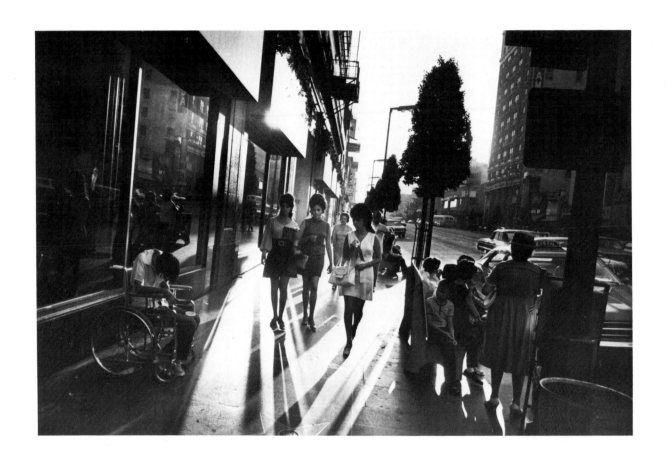

PLATE
99

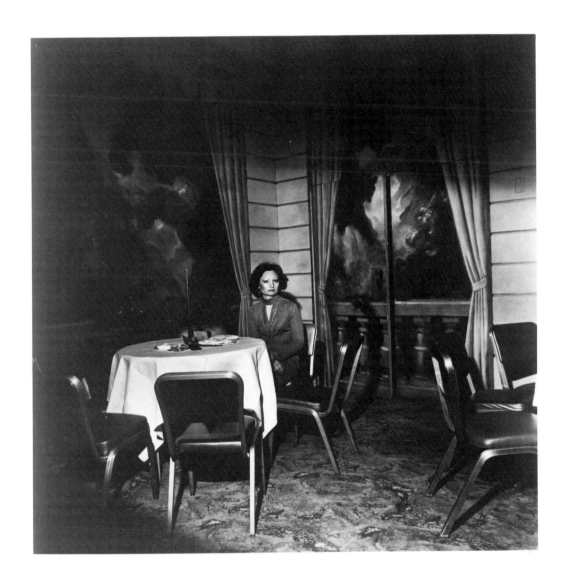

PLATE
100

1. Mathew Brady (1823–1896). Thomas Cole. 1843–48.

Although this portrait of Thomas Cole is one of the earliest photographs shown in this book and a representation of an important American painter, those points are not as interesting as the image it presents of the romantic artist, a dramatic and noble-looking figure with a cape wrapped around his shoulders. It seems unlikely that this is accidental but instead results from a conscious effort by Brady or by Cole himself. It suggests to what extent the seemingly remote America of that era was aware of and influenced by the most current trends in European thought and culture.

2. John Plumbe (1809–1857). Stephen, Henry, and George Childs. 1842.

This is a very early example of the work of John Plumbe, who later established a national chain of photographic studios. Technically it is not as accomplished as his later work, indicating that he was still learning his craft. Still, there is a compelling quality to these stiffly posed figures silhouetted against a dark background, directly confronting the camera and photographer and submitting themselves to a process that, although more commonplace today, had and has an element of ritual and ceremony to it.

3. John Plumbe (1809–1857). Patent Office, Washington, D.C. 1846.

This image is the earliest known photograph of what is today the National Portrait Gallery. It shows Plumbe at the height of his career, using the daguerreotype process with complete mastery. Apart from its documentary content—the glimpses into the yards in the foreground, for example—it is a rich image, filled with textures and carefully recorded tonalities contained within a complexly organized composition. Although it was made during photography's first decade, this image shows how quickly photographers came to recognize and use the medium's unique characteristics to create visually sophisticated pictures that warrant comparison with many images made in the intervening years.

4. Brady and Company. Wounded Soldiers at Fredericksburg, Virginia. May 19, 20, 1864.

The photographic coverage of the Civil War included virtually every aspect of it. This picture may have had some propagandistic function, but it may also have been a symptom of a more generalized urge to document and record. At times it seems that having the capacity to record, the photographers were driven to make pictures, in spite of whether or not there was a demand for them.

The passage of time has clarified the function of this image. Today it is a historical document, giving basic facts about the realities of a major event.

5. Andrew J. Russell (1830–1902). General Meade's Headquarters near Brandy Station. April 12, 1864.

The American Civil War was accompanied by an astonishing amount of photographic activity, and not all of it was the result of the well-known Brady operations. A. J. Russell, for example, was actually an officer who spent much of his time photographing for the U.S. Military Railroad, and most of his pictures deal with that subject. He did, however, photograph other things. This view of General Meade and his staff at the general's headquarters shows a very organized, carefully composed, and artistically conscious approach to picture-making. While there is undoubtedly a definite and essentially documentary intent here, this photograph is equally interesting as an artistic statement.

6. Timothy O'Sullivan (1840–1882). Massaponax Church, Virginia. May 21, 1864 ["Council of War"].

Stopping action was generally not possible with the photographic technology available during the Civil War. It was possible, however, sometimes to suggest a passage of time, and that is what O'Sullivan has done here. In a series of three images, General Grant is shown meeting with his staff. In the first picture he is seated in front of the two trees; in the second he is standing and leaning over General Meade's shoulder, studying the map; in the third he has returned to the bench and is seated, writing. It was a feat for O'Sullivan to capture even this relatively slow action, and undoubtedly it was possible because he was able to anticipate events and had more than one camera prepared and ready to use. In a larger context it reveals the talents that made O'Sullivan one of the most able photographers of his time.

7. Timothy O'Sullivan (1840–1882). A Harvest of Death, Gettysburg. July 1863, from Gardner's *Photographic Sketchbook of the War.*

In the photographs taken by O'Sullivan at Gettysburg, the realities of war are nowhere better shown than in this picture. The bodies are scattered across the field, bloated in the July sun. In making these images O'Sullivan and his employer, Alexander Gardner, present a strong anti-war statement. This image appeared in Gardner's publication, *Photographic Sketchbook of the War,* and was also made and sold as a stereopticon card, indicating the photographers' desire to reach as large an audience as possible.

8. Timothy O'Sullivan (1840–1882). Canyon de Chelley, Arizona. 1873.

This is the earliest photograph of one of the best-known American landscape subjects. The site has been recorded by many photographers since O'Sullivan's visit, and appears in the work of Ansel Adams.

To a large extent the subject makes the picture—great cliffs rising dramatically above the buildings seemingly precariously set into the rock wall. Some study, however, suggests that it is not so simple, and one realizes that con-

sideration had to be given to composition and lighting, and that judgments had to be made to achieve the effects found in this photograph.

9. Timothy O'Sullivan (1840–1882). Shoshone Cañon and Falls, Idaho. 1873.

After the war, O'Sullivan became one of the photographers working with the United States Geological Service surveys of the western states. This was a new kind of work for him, offering as subjects great landscapes with almost unlimited space.

Although there is no evidence that O'Sullivan had any formal art training, a view like this, with its orderly progression of elements receding into the distance, reveals as strong an aesthetic sense as would have been found in the work of any painter.

10. Timothy O'Sullivan (1840–1882). Summit of Walesatch Range, Lone Peak, Utah. 1873.

In this view, which like the previous study has a dramatic sense of space and distance, O'Sullivan again shows his strong compositional skills. The quick transition from the rocks in the left foreground to the figures on the right is an especially striking device, pulling the eye into the picture and at the same time enforcing a sense of overpowering and grand scale.

11. William Henry Jackson (1843–1942). Mammoth Hot Springs, Yellowstone. 1871.

Although Jackson photographed for many years in several parts of the world, his name is strongly linked to the pictures he made in the Yellowstone region. To a large extent because of his photographs, the area became the first national park in the United States. In visual terms it was a subject that almost made its own pictures, and in dealing with these natural curiosities a straight and direct photographic approach was frequently the best one. Even so, Jackson's artistic skills are evident – in this image, just consider the placement of the single figure and the way all the other parts of the scene relate to it, and are organized around it.

12. William Henry Jackson (1843–1942). Upper Fall of Yellowstone. 1871.

Like all of the photographers working in the West, Jackson was impressed by and frequently photographed the grand vistas. In that context, this is a typical image similar to many others made in the West. It is important, however, to remember that this shows a particular place at a definite time, and consider the specifics of the terrain it records – a rugged landscape where movement would have been difficult, and the making of a photograph even more so.

13. Carleton Watkins (1829–1916). Bridal Veil Fall, Yosemite. About 1860.

In addition to the qualities characteristic of other western landscape photography – like scale and distance – Watkins emphasized another quality which was purely photographic, and that was the rendering of textures. The contrasts between the various foliage and rock surfaces are used, along with his strong compositional sense, to create a dramatic image.

The facts of Watkins's life do not suggest any formal or informal study of traditional art, so we are left with the assumption that he acquired his obvious artistic capabilities through a combination of practical work with the medium and an innate aesthetic sensibility.

14. Peter Henry Emerson (1856–1936). "Gathering Water Lilies," from *Life and Landscape on the Norfolk Broads.* 1886.

Only a few years separate the work of Emerson from that of O'Sullivan, Jackson, and Watkins, but that period was marked by a major change in the way photography was perceived and presented. Unlike those earlier photographers, Emerson was consciously and primarily concerned with making photographs as art, and aggressively promoted his theories for achieving this end. He advocated a direct approach to the medium, relying on the control of light, tonalities, and composition to produce his effects. His subjects were supposedly taken directly from nature, but as is fairly obvious in this photography, nature was carefully controlled and arranged in order to produce an aesthetically pleasing image. In addition, Emerson was very aware of the importance of presentation in having photography accepted as art. His prints were made on platinum paper, which allows a long and subtle scale of tonalities, and were issued as limited edition albums.

Although Emerson's work is most properly considered as part of the history of British photography, he had an American father and when young lived in the United States for a time. He is of particular importance to the history of American photography because of his early encouragement of Alfred Stieglitz.

15. Peter Henry Emerson (1856–1936). "Poling the Hay," from *Life and Landscape on the Norfolk Broads.* 1886.

This photograph clearly shows Emerson's control of the structural elements of his picture. From the figure in the right foreground to the dramatic lighting of the horizon, the image is carefully arranged to direct the eye through the picture. While it presumes a certain documentary quality by supposedly showing real people at real work, details are subdued and attention is given to generalized effects that emphasize qualities considered more artistic by the photographer.

16. Alfred Stieglitz (1864–1946). Spring Showers. 1902.

It is possible to find many approaches to subject matter in Stieglitz's photographs. This early work is a carefully controlled composition, the result of thoughtful study of the subject, and at the same time it has an informal naturalism based on common experience. It shows a small event of a kind that many people have known, but paid little attention to.

Stieglitz takes the basic information provided and, through his control of the medium, creates another kind of event that is not limited in time or place.

17. Alfred Stieglitz (1864–1946). Lower Manhattan. 1910.

The city, and more specifically New York City, was a subject of great interest for Stieglitz and one that he frequently used in his work. These images can be found at several points in his career, and show a variety of styles and interpretations.

In this case the idea seems to be that of the large metropolis as a place of massive structures that overwhelm and dominate the individual. At the same time it is an image where aesthetic elements are of great importance. This is a carefully designed composition, with much emphasis placed on pictorial effects that can function independently of the subject matter, but here are used with great skill to visually support the concepts found in that subject matter.

18. Alfred Stieglitz (1864–1946). John Marin. 1911.

Stieglitz felt that a photographic portrait should be more than a physical description of the sitter and should also be a statement about personality and character. In the many portraits found among his works, he employed a variety of means to achieve this end.

This picture of John Marin, an important American painter whose work Stieglitz promoted in his galleries, is a dramatic image that conveys a moody, romantic atmosphere, but provides very few details about the sitter's appearance. It is not so much the photograph of a particular individual as it is a depiction of Stieglitz's concept of the artist as a creative force.

19. Alfred Stieglitz (1864–1946). Dorothy Norman. 1931.

While this is a powerful visual statement and can be appreciated solely for the aesthetic qualities contained within the photograph itself, it is important to know that it was also intended as a portrait. Stieglitz felt that a photographic portrait could not be accomplished with a single image, and that the successful portrait would consist of a series of images done over a period of time. He used this approach most extensively in the many photographs he made of Georgia O'Keeffe, but he also used it with other sitters.

Therefore, while this image of Dorothy Norman can be appreciated and responded to by itself for aesthetic qualities, as a portrait it can be fully understood only in the context of the entire series.

20. Alfred Stieglitz (1864–1946). Lake George. 1935.

In its direct confrontation with the forms provided by modern industrial society, this photograph reflects aesthetic trends that influenced the work of many photographers during the 1920s and 1930s. In the case of Stieglitz, however, it would be wrong to see this simply as a reaction to current trends. From an early point in his work, he was aware of and used the world around him. For example, the study of Manhattan done in 1910 suggests a similar type of response.

What is striking about this later image is the intensity it conveys. Stieglitz has brought the camera close to the objects, photographing them with great clarity and giving the image a degree of reality that surpasses normal experience.

21. Gertrude Kasebier (1852–1934). French Landscape. About 1900?

Gertrude Kasebier was one of the first members of the Photo-Secession group and a major figure in the art photography movement. Trained as a painter and with a knowledge of European art, she frequently used elements from the other media in her photographs. In some cases this was simply a matter of using similiar subject matter, but in other examples she actually manipulated the photographic print to give it a physical appearance more like that of a painting or drawing. She often used the gum bichromate process, which permits one to work on the print with brushes and other traditional tools.

It is difficult to see this image as a photograph. The soft, blurred scene of figures in a landscape is very reminiscent of Impressionist painting, and that this was Kasebier's intention is strongly suggested by the title.

22. Gertrude Kasebier (1852–1934). Florentine Boy. About 1900.

In this image the photographer presents the subject in a format that clearly makes a visual association with Italian Renaissance portraits. The profile view and placement of the figure against a simple background, along with the costuming of the model, are used to create a formal and stylistic connection wth the older art. In some of the first efforts to establish photography as art in the traditional cultural context, some photographers like Kasebier utilized references or "quotations" of subjects and formal devices generally identifiable as being characteristic of the accepted fine arts. As the medium evolved, however, most photographers turned away from these methods to emphasize formal and stylistic elements that were more uniquely photographic.

23. Clarence H. White (1871–1925). Jane Felix White. 1905.

Closely associated with Stieglitz and the Photo-Secession group, Clarence White used photography as a medium of artistic expression throughout his life. His work is especially characterized by its sensitivity to and ability to render the

qualities of light. Using a limited range of subject matter—usually members of his family shown in simple poses—his pictures are striking in their effects, at once direct in their approach and yet mysterious and evocative.

24. Alfred Stieglitz (1864–1946) and Clarence H. White (1871–1925). Torso. 1907.

Collaboration in making a photograph is not as rare a practice as might be thought. During the medium's early years, making a picture often involved one person who selected the subject and arranged the pose, and another who operated the camera. It is not known exactly how the functions were divided here, so credit should go equally to Stieglitz and White.

This image is one of a series of studies of the same model, and perhaps the best known. The nude was a photographic subject from the earliest days of the medium, and was frequently controversial because of the realism photography brought to it. To avoid charges of obscenity, photographers attempted to give nude studies respectability by putting them in a context of accepted art, either through a title—calling it "Venus" or something similar—or by using a visual format that made an association with fine art.

In this image, however, these approaches are largely declined for a more straightforward representation. The forms of the body are used to establish rhythmic relationships that give an abstract structure that controls the picture and counteracts the obvious physical sensuality of the subject.

25. Alvin Langdon Coburn (1882–1966). George Bernard Shaw. 1905.

Most photographic portraiture in the 19th century was formal and stiff. This portrait by Coburn shows the new approach that began to appear around the turn of the century, frequently in the work of photographers associated with the art-photography movement. It is a naturalistic rendering, informally posed, but also one where aesthetic elements are important as effects of light and composition are controlled to make it a visually interesting picture.

To the extent that it is possible to make such judgments, this portrait suggests some effort on the part of the photographer to show the personality of the sitter. The way that Shaw looks off to one side indicates an element of intensity and concentration, making it more than a simple depiction of the subject.

26. F. Holland Day (1864–1933). Nude Youth. About 1900.

F. Holland Day was a contemporary of Stieglitz and the Photo-Secession photographers, but he was never formally associated with the group. He was from a well-to-do Boston family with a good education and the leisure to pursue cultural activities. He had traveled in Europe and was familiar with literature and art, and his ideas were those of one from a cosmopolitan and intellectual elite.

His choice of subject matter frequently reflected his cultural background. This is found, for example, in his interest in the human figure, particularly in nudes. These were often male nudes, shown with pronounced romantic and emotional overtones rarely seen in the work of most of his contemporaries.

27. F. Holland Day (1864–1933). Portrait of a Lady. About 1900.

This portrait is an excellent demonstration of Day's skill in using the photographic medium as an expressive tool. He does more than simply record the appearance of his subject, arranging areas of light and dark and setting up the pose to suggest the subjective aspects of an individual personality within an artistically expressive format.

28. Detroit Photographic Company (1898–1924). Old Fish House. About 1900?

By many definitions this would certainly be considered an artistic photograph. It has a picturesque subject matter set in a format with a balanced composition, and emphasizes the textures, tonalities, and reflections that are so well rendered by the photographic process. In spite of that, it was not sold or presented as a work of art so much as it was simply a picture to be looked at and enjoyed. The actual difference between this image and one made by a self-conscious artist-photographer would be difficult to measure, being more a question of how the image was presented than any matter of quality. Although the Detroit Photographic Company was not in any way connected with the concurrent art-photography movement, the pictures the Company made and sold obviously responded to a taste and demand for visual communication and expression that existed on many levels and in many parts of society.

29. Seneca Ray Stoddard (1844–1917). Drowned Lands of the Lower Raquette, Adirondacks. 1888.

Stoddard operated a commerical studio in New York State and over the years specialized in producing photographs of the Adirondack region, which were largely souvenir pictures for the many tourists who visited the area. His pictures were also frequently published in books. Beyond taking views of all the popular sites, Stoddard produced some images of unusual quality and interest which raise questions as to how they were received and perceived. This view of the drowned lands is a mysterious, moody, and romantic scene, filled with a sense of foreboding. These qualities seem too evident for this to be dismissed simply as latter-day reinterpretation, and somehow, to some extent, must have been intended by the photographer.

30. Seneca Ray Stoddard (1844–1917). The Woods in Winter, Adirondacks. 1888.

As is the case with the view of drowned lands, this scene by Stoddard of a snowstorm is a striking and moving image. Images like this are not characteristic of most of his pho-

tographs, but similar scenes appear frequently enough to justify classifying them as conscious expressive statements. Whether or not Stoddard and those who used his pictures thought of them as art is perhaps not relevant, for it is possible to find here another indication that while photography utilized many of the elements of traditional visual art, it was not the same thing, serving as it did in some cases as a surrogate for the basic experience of reality – a reality that in some cases the viewer would not want to know directly; it was art, but also something more than art.

31. John C. W. Grabill (Dates Unknown). Indian Teepee. 1891.

One of the subjects most frequently used by photographers at the end of the 19th century was the American Indian, and in some cases their involvement with this subject was so extensive that it dominated their work. The variety of approaches found in these pictures again demonstrates the range of expression to be found in the medium. Grabill's approach in this picture is basically that of simple recording, showing things as they were at a specific moment. There is little editorializing and little sense of any attempt at artistic presentation.

32. Edward S. Curtis (1868–1954). The Wind Doctor [Nesjaja Hatali – Navaho Medicine Man]. 1904.

Curtis's involvement with the Indian was beyond that of any other photographer. For a period of thirty years he worked to document what he considered a dying culture. His was not, however, by any means a factual record. Compare this image with that of Grabill (no. 31), and it is obvious to what extent it is an artistically manipulated, romantic vision conveying the concepts of white European civilization. Some of the most interesting aspects of Curtis's work are found in his portraits, which are probably more significant as examples of the use of photographic technique and the depiction of individual personalities than as anthropological or historical studies.

33. Frances Benjamin Johnston (1864–1952). Studio, Washington, D.C. About 1900.

Johnston's long career involved several different types of photography. During much of the 1890s she operated a fashionable portrait studio in Washington and had as subjects many prominent individuals from government and society. This photograph shows her studio, and it is a valuable document giving information about the medium itself and the environment in which it functioned. The most striking element is perhaps the large skylight window, which reminds us that this was a time when natural light was the primary source of illumination. Such a window, with the curtains that were used to control the intensity of the light, would have been found in many studios.

We also see the large studio camera, but perhaps more interesting are various studio props like the posing chair, the tigerskin rug, and the draperies and background screen.

These devices were important for staging the portrait and conveying the image desired by the sitter. To a lesser extent they are a reflection of the taste for exotica found in some parts of American and European society and culture during these years.

34. Frances Benjamin Johnston (1864–1952). Home-mixing of Fertilizers, Tuskegee Institute. About 1900.

This is one of a great number of photographs Johnston made of Tuskegee and other Black schools around the turn of the century. These images were intended to document the progress American Blacks had made since the Civil War, and there is basic information to be found in these pictures. Today, however, they are more likely to be viewed as works of art because of the obvious care with which each scene was arranged, lighted, and photographed. If one were looking for an illustration of the basic elements of photographic art it would be difficult to improve on this, and yet it was not made to be a work of art. This is a paradox found throughout the history of photography, where the conception and definition of art has been and continues to be a matter of discussion and redefinition.

35. Frances Benjamin Johnston (1864–1952). Talbot County, Maryland. West Martingham Outbuildings. About 1930.

During the latter part of her long career, Johnston devoted herself primarily to photographing architecture, and was involved from an early stage with important documentary surveys of American architecture. Her work, as this example shows very well, established a high standard. All of the architectural-survey projects that have followed her pioneering work are measured against it.

36. Arnold Genthe (1869–1942). Chinatown. About 1895.

Genthe's Chinatown photographs are only a small portion of his work, but they have great importance as early examples of expressive documentary photography. In these pictures Genthe was not so much attempting to record facts as he was trying to convey an impression. To this end he frequently manipulated his images by cropping and varying the printing so that often the finished print is very different from the original image on the negative.

37. Arnold Genthe (1869–1942). Profile of Gertrude Eddington. About 1910.

It is interesting to know that although this was a photograph of a specific individual, Genthe chose to see the image in a different context. For him the most important element was the visual association with classic Greek sculpture, and in making the photograph he manipulated light and dark to emphasize the third-dimensional quality. In his autobiography, As I Remember, Genthe discusses this photograph and specifically mentions it in comparison with the Venus de

Milo. Since Genthe had a classical European education and was thoroughly familiar with the ideas and images of western culture, references to them in his photographs are natural and consistent with his theories about art.

38. Arnold Genthe (1869–1942). The Boss of the Fish Dealers Court, New Orleans. About 1920.

Throughout his career, Genthe brought to his photography preconceptions and opinions that frequently caused him to manipulate and change an image until it fit his ideas. This practice is found in many of his Chinatown photographs, and again in this picture, where the scene is photographed and printed to give it a dark, mysterious quality. This is in no way factual documentation of New Orleans, but instead a romantic fantasy showing a place that never actually existed.

39. Arnold Genthe (1869–1942). Greta Garbo. About 1928.

Genthe made a number of studies of Greta Garbo and felt that his photographs had an important effect in establishing her career in this country. Today these images are an important part of the history of photography, and show the expressive qualities of what has sometimes been considered an impersonal technology. These qualities are even more strikingly shown when Genthe's photograph is compared with Edward Steichen's image of the same subject (no. 47).

40. Arnold Genthe (1869–1942). Marion Morgan Group II. About 1930.

Although not quite as well known as his Chinatown pictures, Genthe's dance photographs are important in terms both of his work and of the general history of photography. Genthe was among the first to attempt to capture the movement and grace of dance within the limits of still photography. In so doing he also tried to create a photograph that was in itself a beautiful image, combining the artistic qualities of the subject with those of the photographic medium.

41. Lewis Hine (1874–1940). Little Orphan Annie in a Pittsburgh Institution. 1909.

Photography used as a medium for active didactic and persuasive expression found one of its most energetic practitioners in Lewis Hine. Throughout his career he was involved in working for a number of causes and purposes. One of his most important efforts was for the National Child Labor Committee, for which he documented many instances of child labor throughout the country. His pictures and the information they provided helped in making the laws that were enacted to control child labor. His concern for the subject and the message was combined with a highly developed aesthetic sense that is revealed here in his use of composition and placement to create a dramatic visual framework.

42. Erwin E. Smith (1888–1947). Storytelling in Matador, Texas. About 1910.

Erwin Smith is an excellent example of a kind of photographer whose importance is determined to a large extent by the subject matter of his images. Frequently an amateur, the photographer overcomes technical difficulties and concentrates on his material with a single-mindedness that is often overwhelming in its comprehensiveness.

Such efforts are usually of greatest importance as documentary records – and that is largely true with Smith – but not infrequently it happens that the photographer, perhaps because of the duration and intensity of his use of the medium, develops an obvious aesthetic sensibility.

That would seem to be the case with this photograph. It is a dramatic and striking image that suggests an element of control and manipulation on the part of the photographer, but even if this is so, it does not interfere with the primary documentary function of the picture.

43. Charles Sheeler (1883–1965). New York City. 1928.

In the 1920s Charles Sheeler continued concepts of expressive photography that came out of the work of Stieglitz and his associates. The fundamental concept was that of photography as art based on elements characteristic of the medium. One of these elements is of course its ability to render physical reality. In Sheeler's study of city buildings we are aware of them as physical objects with a material reality, and yet the photograph does not give much actual information. This is essentially an abstract composition, made out of the photographic rendering of spatial relationships, contrasts of light and dark, and various material textures and surfaces.

44. Charles Sheeler (1883–1965). United Nations Building, New York City. 1951.

Many of Sheeler's photographs deal with architectural subjects, and often he is interested in them as sources of dramatic, expressive form. In this study of the UN Secretariat building there is a minimum of factual information – but still enough to identify the structure – and the emphasis is on conveying the sense of a powerful abstract force rising into the sky. It also produces a feeling that is, when we think about it, very realistic and close to the sensations experienced when standing at the base of a tall building and looking upward to its top. In that, it becomes much more than the record of a particular building and moves into the realm of universal experience.

45. Charles Sheeler (1883–1965). Fuel Tanks, Wisconsin. 1952.

An interest in structural form appears in much of Sheeler's work. Although he was equally known as a painter, his photographs were sometimes made as studies for paintings, but in almost every instance the photographs also functioned independently. There are also photographs that, while they

show a concern with structural elements, also have an expressive quality about them that makes them more than studies of abstract form. Here, a view of a simple subject with very elemental forms is photographed in diminished light and becomes an image dominated by an air of forbidding mystery, conveying a romantic quality not always found in Sheeler's work.

46. Edward Steichen (1879–1973). Sunday Papers: West 86th Street, New York. About 1922.

Although much of our response to this photograph is conditioned by the title, much is also dictated by Steichen's skill in using the medium and working with its unsurpassed ability to render detail. Ordinary objects of everyday life like a broom, a trashcan, and the textures and patterns of a brick wall, together with the depiction of a common and familiar activity, are brought together to make an image that goes beyond the specifics of the title and becomes an event complete within itself.

Reprinted with the permission of Joanna T. Steichen.

47. Edward Steichen (1879–1973). Greta Garbo. 1928.

This is one of the best-known images of Garbo, and offers an interesting comparison with Arnold Genthe's study (no. 39). In Genthe's picture the emphasis is on the actress herself, and on a sense of her personality. In Steichen's photograph there seems to be a greater emphasis given to the image as an object in itself. To a large extent it is an exercise in graphic design, an arrangement of light and dark shapes where the face of the sitter is somewhat obscured and perhaps lost in the overall structure of the image.

Reprinted with the permission of Joanna T. Steichen.

48. Paul Outerbridge (1896–1959). Umbrella. 1924.

Outerbridge was one of the first American photographers to use the forms of everyday objects as a primary source of subject matter. Emphasizing fundamental shapes and textures, he transformed incidents of seemingly casual observation into precisely organized geometric compositions that function as self-sufficient works of art.

49. Paul Outerbridge (1896–1959). Telephone. 1923.

In the years following World War I, artists became increasingly aware of the expressive potentiality to be found in the forms of contemporary industrial products. Here the photographer has seen the shapes of a common everyday object in a way that creates a composition of interlocking circular elements, still recognizable as a telephone, but now transformed into an experience that is primarily one of aesthetics rather than of information.

50. Paul Strand (1890–1976). Men of Santa Anna – Michoacan. *Photographs of Mexico.* 1940.

This image could be used as a definitive example of what has been termed "straight photography." It is an approach that has qualities of documentation, but essentially is not that. In truth the picture gives one a minimum of factual information, being little more than a physical description. What we see is what we know. We do not know these men as specific individuals, but rather as a generalized type, Mexican peasants, who, in spite of the seriousness with which they are shown, have a quality of the picturesque about them. Still, this is a strong, affective image, which fulfills the functions of art while remaining essentially photographic. The combination of formal structure, photographic elements, and subject matter produces an object that exists independently of all these and is to be considered and enjoyed for its own sake.

51. Doris Ulmann (1884–1934). Negro Woman with Scrubboard. 1930.

Doris Ulmann's photographs are like those of Paul Strand in that there is a certain contradiction between the reality of the original subject matter and the photographic form it is given. Ulmann presents a somewhat romanticized image of poverty, using subtle tonalities and soft focus to counteract the factual realities, and the calm and dignified pose of the figure makes more of a statement about the woman as an individual personality than it does about her physical and economic condition.

52. Doris Ulmann (1884–1934). William Campbell, Abington, Virginia. About 1930.

This photograph has some of the same sense of contradiction found in the image of the Black woman, but with an interesting variation. Although it is known that this shows one of the mountain people Ulmann spent so much of her time photographing, the pose and depiction of the subject have elements of a formal studio portrait. Except for the details of his clothing, this man might be taken to be a successful businessman or professional man, and perhaps that is not so surprising since before she photographed the people of Appalachia, Ulmann had done a series of portrait studies of prominent men in science, business, and the arts.

53. Man Ray (1890–1976). Rayograph. 1927.

It is interesting to realize that this image was made at approximately the same time as Strand and Ulmann made their photographs. It shows the range of expression that had become possible in the medium during the one hundred years since it was invented. Although this is an abstract image, it is arrived at by a manipulation of the same photographic elements used in the other pictures. It shows how photography can be used for purely artistic expression, exploiting the medium's unequaled capacity to record details, textures, and tonal gradations as expressive qualities seen for their own sakes.

54. Man Ray (1890–1976). Portrait of Marcel Duchamp. About 1930.

At first glance this appears to be a relatively straightforward profile portrait, but the closeness of the subject and the contrasty rendering of form give it a dramatic quality that make it more than a simple portrait. The photographer also uses a technique known as solarization, which makes a sharp line appear along the edges of shapes and gives them added emphasis.

Since we know that Duchamp was a leading figure in avant-garde art along with Man Ray, it does not seem unreasonable to suggest that Ray was attempting to present more than a physical description and sought through his manipulations of the medium to convey some notion of Duchamp's personality.
Copyright © ARS N.Y./A.D.A.G.P., 1989

55. Samuel Gottscho (1875–1941). Schrafft's Window. 1939.

This photograph was made as a record and document, but because of its skillful use of basic photographic controls, it creates an image that offers more than information. Contrasts of light and dark, textures, shapes and forms contained within the picture function independently of the described facts to produce reactions that are primarily aesthetic.

This image shows again how the perception of any photograph is a process of evolution, and how, once made, it assumes an independent existence.

56. Samuel Gottscho (1875–1941). Fireworks at New York World's Fair. 1939.

This photograph originated as a historical document verifying and illustrating a specific moment and event. It is also an example of the capacity photography has to show things that cannot really be seen. The actual fireworks lasted only for a moment, but the technology of the medium is able to record them and transform the moment into an experience unlimited by time.

57. Theodor Horydczak (1890–1971). Gasoline Engine Blocks, Maytag Washing Machine Company, Newton, Iowa. About 1930.

Although it was a commercial assignment, this photograph clearly shows a consciousness of then current aesthetic trends in photography. In the 1920s, many photographers involved with making artistic statements turned to the forms and designs found in industry as a source of inspiration. There are examples in the work of Edward Steichen, Paul Strand, and Charles Sheeler, and it is interesting to find the same approach and subject matter here. The photograph shows on one hand the extent to which a common formal syntax had developed in the medium, but it also shows to what extent the status of any particular photograph can be determined by external circumstances. Is Horydczak's photograph any less a work of art than similar images by the above individuals because it is not as well known? Looking at this image and noting the obvious skill with which it has been observed make it difficult to support such a judgment.

58. Theodor Horydczak (1890–1971). Street Vendor with Balloons, Washington, D.C. About 1933.

Horydczak operated a commerical studio in Washington from the early 1930s into the 1950s. Most of his photographs were done for industrial and business clients and showed their products and services. Occasionally he turned his camera on other subjects that did not have such clearcut purposes. This image could for example be taken as an illustration of a picturesque character in the city, but if one notices the date, 1933, which places it at the height of the Great American Depression, then it could be seen as reportage and possibly a comment on the social and economic conditions of the time. This was a period when street peddling was the only way for many people to earn a living, and perhaps the photographer was responding to this situation. However, the question must remain unanswered, since the photographer himself left no information about the picture.

59. Theodor Horydczak (1890–1971). Dance Floor, Shoreham Hotel Garden Room, Washington, D.C. 1934.

This striking image is yet another example of how the photographic process can transform our perceptions of reality. As we look at this picture we see an abstraction, a pattern of white spots concentrically set around the core in the lower left, and it is only with a mental and visual effort that these are transformed into people and tables. There is also a suggestion that the photographer possessed a highly developed aesthetic sensibility that functioned no matter what the given purpose of the picture was to be. We may no longer know the intended use of this photograph, but because of the skill with which it was made, it assumes a status unaffected by that original function.

60. Berenice Abbott (1898–). Blossom Restaurant, The Bowery. 1930s.

The importance of this photograph can be found in the information that fills the picture, giving us a sense of everyday economics for a time now past. Whether or not this was the intention, however, is largely irrelevant, since the ultimate function of all the signs and lettering is that of formal elements that establish the composition of the image and give it visual texture.

61. Berenice Abbott (1898–). Factory Warehouse, Brooklyn. 1930s.

In much of her work, Berenice Abbott uses an approach sometimes referred to as straight photography. It could also be thought of as documentary, for one of its characteristics is a direct and precise depiction of the subject matter. There is no manipulation of the material other than selecting the view from which the object will be shown. The visual inter-

est of the picture comes from what is found in the subject, from the varieties of light, texture, and shapes that it offers to the camera.

62. Walker Evans (1903–1975). New Orleans Garage Mechanic. 1936.

The formalism seen in the work of Man Ray and Paul Outerbridge did not make a significant impression on photography in the United States until after World War II. It was, however, still to be found, and nowhere is this more clearly seen than in the work of Walker Evans. While this is very much a portrait of a specific personality, the image is highly structured, an effect achieved primarily by the centralized placement of the head, which is lighted in a manner that emphasizes the physical structure and patterns found in the elements of the face and clothing. In addition to this formal structural control, Evans also used the personality of the subject as a positive element. The direct, straight-on confrontation with the head and shoulders forces the viewer to consider the individuality of the subject on a personal level, apart from any consideration of the overall formal structure of the picture, and yet because the latter is so strong, it tends to influence our reaction to the subject, reinforcing the sense of a strong personality.

63. Walker Evans (1903–1975). Negro House, Tupelo, Mississippi. 1936.

One might initially respond to this image because of its formal structure, which has several interesting aspects. Purely photographic elements, like the play of light on textured surfaces, are combined with the rigid geometric composition formed by the house in the foreground. This is contrasted with the right third of the picture which shows an open space where in the distance another building echoes the one in front. Visually it is a complicated and aesthetically sophisticated picture, and our consideration of it could stop there, but we cannot do that. Evans has given the image a specific title, thereby making what might be a purely aesthetic statement into an emotionally charged image with overtones of social criticism. The elements that were seen as textures and compositional devices can now be taken as evidence of social and political wrongs. This would seem a radically different message from that first stated for this photograph, and, to a large extent, it is. What this does point out so well is the underlying subjectivity of all visual communication and how, even in the case of a medium so much based on objectively perceived visual realities, meaning is controlled by the context in which the image is perceived.

64. Walker Evans (1903–1975). Church Interior, Alabama. 1936.

As is the case with many of Evans's other photographs, this image shows ordinary objects in a simple setting, and transforms them through the imposition of visual structure and precise recording of tonalities, textures, and details. All of these elements are brought together within the boundaries of the picture format to make an image that contains in itself an intense physical presence surpassing the reality found in the subjects actually described.

65. Walker Evans (1903–1975). Roadside Stand, Vicinity of Birmingham, Alabama. 1936.

The emphatic symmetrical composition of this image is a quality found in many Walker Evans photographs. Its presence gives visual unity to a picture filled with information that includes informal portrait studies and a detailed record of vernacular architecture. Evans integrates these elements, giving people and surroundings equal visual weight to convey a pictorially effective rendering of the feel and texture of this particular environment.

66. Dorothea Lange (1895–1965). Nipomo, California ["Migrant Mother"]. March 1936.

It is very likely that "Migrant Mother" is the best known of the many photographs made for the FSA project. It is so much a part of our common visual culture that it is difficult to look at it without preconceptions. It is also a picture that carries meanings far beyond what was originally intended. We know that the image is one of a series made to document the conditions of migrant workers in California in the 1930s. The entire series of pictures would show how the photographer worked in a deliberate manner, moving from a general view to the final close-up, recording along the way a number of details about the subjects, their physical condition and environment. The final image, however, transcends much of this factual information by deemphasizing or eliminating it–for example, by concentrating on the face and arms of the woman. We know that this was a particular individual, but in this format, it is a larger symbolic meaning that prevails. Viewers see this not as a particular woman, but as an image of womankind and one aspect of a universal condition.

67. Dorothea Lange (1895–1965). Abandoned Farmhouse, Texas. 1938.

This is a photograph that functions equally well as documentation and as an aesthetic experience. Lange's study of the drought-ravaged landscape is a dramatic image that gives a strong sense of a desolate and hopeless situation. At the same time it is a visually striking composition, setting the curving lines of the plowed field against the smooth expanse of blank sky and placing the farmhouse as a small point of emphasis between the two larger elements. To a large extent the effectiveness of the photograph's message is determined by this skillful use of these formal devices.

68. Dorothea Lange (1895–1965). Child Living in an Oklahoma City Shacktown. 1936.

This photograph serves, as do so many FSA images, as a record of the widespread poverty that existed in the United

States during the 1930s, and was made as part of the efforts to change these conditions. But with the passage of time the picture has become more than documentation or propaganda and is now a universal statement about the human condition. This is not so much the result of any outstanding technical or artistic skill on the part of Dorothea Lange, as it is because of her obvious empathy with the subject—a quality that must remain essentially undefinable but that is nonetheless a pervasive force in her work. To some extent it may come from her method of meeting the subject directly and closely, but as one finds here, the image projects an intensity that surpasses all methods and facts and moves into the area of aesthetic experience.

69. Carl Mydans (1907–). Migrants on the Road— "Damned if we'll work for what they pay folks hereabouts", Crittenden County, Arkansas. 1936.

Carl Mydans was associated with the FSA project for a brief period and then went on to a long career with *Life* magazine. His work is a small part of the FSA archive, but it was important for helping establish the project's style and attitude. This method is clearly seen in this image, where the title, a quote from the subjects, largely determines the message of the photograph—a device frequently used with FSA images and often responsible for establishing their effectiveness. Without the title this picture could be seen as a study of two picturesque types walking along a country road. By itself the image offers a dramatic use of visual elements, like the converging lines of the road and the great expanse of sky to emphasize the figures. But by combining these formal elements with the information given in the title, Mydans creates a complex image that conveys a strong message.

70. John Vachon (1914–1975). Grain Elevators, Omaha, Nebraska. 1938.

Vachon is different from most of the other FSA photographers in that he became a photographer after beginning to work for the project. Originally hired to work in the office, he started to take pictures and learned by looking at the work of the other photographers and through contacts with them. He ultimately became one of the primary photographers for the project and produced a body of fine work.

Although his photographs show the same range of subject matter found in all FSA images, Vachon had a special sensitivity to the texture and form of the landscape and the objects found in it. An example like this provides the basic facts about the shape of grain elevators, but it is more impressive as an abstract, formal study that functions without any reference to the given information.

71. Gordon R. Parks (1912–). Government Charwoman Who Provides for a Family of 6 on Her Salary of $1080.00 per Year, Washington, D.C. August 1942.

Gordon Parks was not actually part of the FSA photographic unit, but he worked on several special projects with the group's director, Roy Stryker. These studies have become an important part of the archive.

Among Parks's projects are some studies of Black Americans that were among the first efforts to present a comprehensive and accurate view of their conditions. The image shown here is not the best known from this study, but it shows very well how Parks used photographic controls, manipulating light and compositional elements to make a dramatic and effective picture.

72. Ben Shahn (1898–1969). Waiting for Relief Commodities, Urbana, Ohio. August 1938.

The degree to which the meaning of a photograph is conditioned by the information brought to it is shown very well in this image. Provided with the caption, we respond to it as a historical document, a record of one aspect of the problems the United States faced in the 1930s. Without this information, however, the meaning can be quite different. It can, for example, be seen as a character study—old age and youth—one of those generalized concepts that appear so often as a subject for popular culture. It can also be looked at in terms of its composition and structure, which is a complex organization of shapes and textures built around a strong central vertical axis. The repetitious positions of the figures and the shapes of the hats are obvious compositional devices, and reflect the artistic training of Shahn, who is perhaps better known as a painter and draftsman than as a photographer.

73. Arthur Rothstein (1915–). Bleached Skull of a Steer, South Dakota. May 1936.

This is another FSA photograph that has received a lot of attention and caused a certain amount of controversy, largely for nonphotographic reasons. Most of the controversy had to do with whether or not this was a manipulated image, since the photographer did pick the skull up and move it to make a better picture. Much of the difficulty arose because the picture was taken by some as a specific record, and they felt that it gave inaccurate information. It should not be seen as a specific document, but instead as a broad statement, an image that is more significant as an example of the use of photographic skills, where elements of selection and placement, texture and light, pattern and shape, are all used to make a picture that states fundamental concepts of drought and death.

74. Russell Lee (1903–1986). Catnap—4th of July, Vale, Oregon. 1941.

Most of Russell Lee's photographs show a sympathetic feeling for his subjects, and often there is a touch of gentle humor. This image can be appreciated for formal qualities like the composition set up by the positioning of the figures and the spacing of black and white areas throughout the picture, but there is no doubt that the primary effect comes from its warm depiction of a moment of relaxed intimacy between ordinary people.

75. Jack Delano (1914–). Foggy Night, New Bedford, Massachusetts. 1941.

This photograph does not seem to fit the documentary functions usually associated with FSA images, showing as it does a romantic and somewhat mysterious scene that does not give a highly factual view of New Bedford. There are other pictures like this found throughout the FSA archive, and it has been suggested that they are the result of something as ordinary as the need for the photographer to finish using up a roll of film.

Whatever their origin, these images give an added interest to the archive, and show again the flexibility of the photographic medium. Taken for itself, this image captures a moment in time that is a universal experience, and one that photography is particularly able to record and present.

76. Jack Delano (1914–). A Scene on a Rainy Day of the Farm of Mr. Addison, Westfield, Connecticut. 1940.

Here is another image from the FSA archive with seemingly minimal documentary content, offering instead a scene that conveys a subjective, moody atmosphere. Delano was trained as an artist, and was undoubtedly sensitive to the expressive potentialities of photography. In this image he contrasts the precisely focused jars and bottles of the foreground against the blurred forms of the landscape seen through the window to create a tension that gives the photograph formal unity.

It is possible of course to see documentary elements in this image—the objects depicted were an actual part of Mr. Addison's farm, and their presence suggests its physical materiality—but with the photographer's manipulations their original function as record becomes one of expression.

77. Marion Post Wolcott (1910–). Playing Checkers, Greensboro, Georgia. 1939.

Although this is a technically competent photograph, it is not of interest primarily because of its formal and stylistic elements. As is the case with many of Wolcott's images, the strength is in the subject matter and the information it provides. This picture can be viewed on the simplest level as a picturesque genre study, showing a charming view of rural, small-town life. It is, however, a much more complicated image. Given the basic information as to the time and place shown, we are presented with a historical document that first provides a physical description and then gives some information about the people depicted—their forms of recreation and, although perhaps not as obviously, an indication of social relations, with the inclusion of the two Black men on the edge of the group.

78. Marion Post Wolcott (1910–). Snowy Night, Vermont. 1940.

People and their activities were the subject matter for most FSA photographs. Occasionally there were exceptions. Landscape subjects might serve in some instances as background information for a larger study, but there were also examples where an aesthetic impulse seems to be the primary motivation. This picture is one to which it is easy to respond—the texture of the snow, the effects of the light, and the peacefulness of the scene form a familiar imagery that is satisfying and comforting.

79. Russell Lee (1903–1986). Soda Jerker Flipping Ice Cream into Malted Milk Shakes, Corpus Christi, Texas. February 1939.

This photograph is quite easily seen as a document of American culture. The drug store with its soda fountain was for a long period one of the most typical parts of American society, and it is a type of subject found in many of Russell Lee's photographs.

This image can also be seen solely in terms of the photographic medium, for it is a picture possible only through this medium. Elements like the scoop of ice cream stopped in air by the flash, the foreshortened views of the hands and arms, and even the reflection of the flash in the background mirror can be seen only through the mechanism of the camera and the action of the photographic process. Although Lee's picture was made for other reasons, it is taken by some contemporary photographers as an ancestor of their work, which often concentrates on these photographic elements and makes them an end in themselves.

80. Barbara Morgan (1900–). Martha Graham: Ekstasis. 1938.

Although the prevalent uses of photography during the 1930s were mostly documentary, like the FSA project and the work for picture magazines such as *Life*, the aesthetic approach also continued and evolved. Photographers worked with principles established at the turn of the century by the Photo-Secessionists, and also drew upon qualities inherent to the medium. Much of this can be seen in the photographs of Barbara Morgan, who made an extensive study of dancers in the 1930s, and especially of Martha Graham. These images might be considered documentation, but they are also the result of premeditated study and carefully controlled technique. In some cases like this the image seems to move far from documentation. We can identify the subject in a specific manner, but the cropping and

lighting work against this specific identification by suggesting classic Greek art and notions of ideal form. This is a complex image, expressing generalities through specific realities.

81. W. Eugene Smith (1918–1978). Saipan. 1944.

Among other things photography has brought to people is a larger sense of the realities of warfare. It was a subject that fascinated photographers from the beginning, and has continued to do so. It is unfortunate, but many of the images that have become part of our common visual culture deal with this subject. For most people war is not a direct experience, but is known through secondary sources that in our time are usually visual. Smith's photograph of a specific incident during the Pacific war can also be seen as a general statement about the effects of war on the innocent, and it can also be admired for the artistic skill with which the grim realities are rendered.

Copyright © The Estate of W. Eugene Smith.

82. Toni Frissell (1907–). Blitz Victim, London. 1945.

Although she worked primarily as a fashion photographer for most of her career, Frissell was a war correspondent during World War II and produced a number of documentary studies. This picture is probably the best known of these images. It shows the specific realities of destruction and human suffering that are a part of war, but it is also a paradigm of all victims, carrying a range of meanings and associations that extend far beyond the original event.

83. Toni Frissell (1907–). Midsummer's Night Dream. 1947.

During the 1910s and 1920s fashion photography began to appear as an independent form of expression, and by the 1940s it was a major area for creative work. Its images were of course made to fulfill a definite end and purpose of promoting and selling, but fashion photography still became and has remained a format that allows great freedom for the expression of visual ideas. Toni Frissell's work was among the more imaginative, as this image demonstrates. It shows a factual situation that we know actually existed, yet quickly moves beyond that into a realm of dreams and fantasy, which is of course a major element of fashion.

84. Edward Weston (1886–1958). Tomato Field. 1937.

The material realities depicted in this photograph are perhaps more pleasant and informative than those shown in Weston's later image of a dead pelican, but the fact remains that this image is equally as formal, and just as concerned with the presentation of photographic realities as ends in themselves. The most important element here is not the physical description of the tomato field, but rather the patterns and structure the rows of plants form when photographed.

© 1981 Center for Creative Photography, Arizona Board of Regents.

85. Edward Weston (1886–1958). Dead Pelican. 1945.

It could be stated that photography as a medium for essentially aesthetic expression reached a point of almost complete fulfillment in the work of Edward Weston done during the 1930s and 1940s. In this photograph the use of the physical and technical elements of the medium is such that it produces a positive aesthetic response in spite of the subject matter. The factual information presented here, a dead pelican floating in a debris-filled pool, is counteracted and made irrelevant because of the photographic rendering of textures, values, and shapes. Details are transformed, and we see patterns of sparkling light, complex shapes, and layers of space. For the most part we do not think about depicted realities, choosing instead to concern ourselves with the realities of the medium present in the physical artifact.

© 1981 Center for Creative Photography, Arizona Board of Regents.

86. Imogen Cunningham (1883–1976). Helen Mayer. 1936.

The effect of any portrait greatly depends upon the sitter and the nature of the individual personality, but the photographer can often contribute to the process through controls used in making the picture. In this image, Cunningham uses one of the oldest devices of portraiture, the significant accessory. Whether or not it was an accurate view, by posing Helen Mayer with a fencing mask and epée, and having her confront the camera with direct intensity, the photographer creates a strong and striking image.

87. Imogen Cunningham (1883–1976). David Park. 1956.

David Park was an artist, but there is nothing in this photograph that gives any indication of that. The information found here is minimal, and our response to the image comes from a sense of personality projected by the sitter.

To a large extent this image also succeeds because of the direct way the photographer presents the subject, isolating the figure against the background and clearly showing the physical details that define and establish personal identity. This photograph may not in itself tell us that the sitter is an artist, but it does convey a sense of a strong and unique individual.

88. Lisette Model (1906–1983). Singer at Cafe Metropol, New York City. About 1950.

A photograph can be a variety of things, ranging from simple record to an artifact of beauty that is a self-sufficient aesthetic experience. This image is neither of these, but represents an approach to photography that reflects ideas

also found in the larger world of advanced art. It shows an attitude that rejects older ideas of beauty and taste, and concentrates on a notion of confrontation with the world, and the depiction of experiences and events that often have a quality of high tension about them. In some cases it involves subjects and situations that would be considered ugly and unpleasant—and not what most people would think of as being art. In making photographs like this, Model sometimes appears to be primarily interested in shocking the viewer, but she is also placing a challenge to see the world in all of its aspects and suggesting there is no limit to the definition of art.

89. Ansel Adams (1902–1984). Redwoods, Bull Creek Flat, Northern California. 1960.

Ansel Adams's photographs are known for technical excellence and their use of photographic elements to achieve the fullest range of aesthetic expression, but they are equally important because of the concepts presented in their subject matter. Adams's depiction of a heroic and romantic western landscape reflects a primary theme in American thought that dates back to the 19th century. The notion of overwhelming and unlimited nature has been an important subject in many forms of American art, and Adams's photographic interpretations have become a major part of this cultural and artistic heritage.

90. Harry Callahan (1912–). Eleanor, Chicago. 1953.

Although it is clearly identified as to subject, place, and date, this photograph is not concerned with that kind of information. It is instead an image primarily involved with art, and how artistic concepts are presented in this medium. The important elements here are shapes and textures, all combined in a carefully arranged composition. The rigid symmetry of the strong foreground vertical formed by the figure and the pole is set against the somewhat irregular horizontals of the buildings and street. Areas of light and dark tonalities are balanced against one another, as are the different textures of bricks and walls. It might be possible with this same subject of a solitary figure in an urban landscape to present a picture with a documentary and ideological message, but by so strongly stressing form and structure, Callahan creates an image that is largely about photography and art.

91. Aaron Siskind (1903–). Chicago #12. 1960.

This study of chalk marks on a wall is similar to the Callahan photograph in that it is self-contained and mostly concerned with aesthetic expression. Siskind emphasized his interest in this approach by using a subject that is difficult to identify and has little obvious relationship to a larger environmental context. This photograph can be experienced only

in terms of textures, shapes, and values. Its success is largely a matter of responding to the tension established by the two chalk marks and the large gray rectangle in the lower third of the picture. It is very much a part of its time, showing the concern with abstraction that dominated the visual arts of the 1950s and 1960s.

92. Minor White (1908–1976). "Windowsill Daydreaming, 1958," from the *Jupiter Portfolio.* 1975.

While one might first think that this photograph is primarily concerned with abstract patterns of form and texture, and the varying qualities of light striking and penetrating different surfaces, there would seem to be more than that. The depicted facts consist of a moment of light caught on a wall by an open window, one of those incidents frequently experienced and quickly forgotten. By photographing this small event, White preserves it and places it in another context, where the viewer is invited to study it and meditate, possibly moving beyond the depiction of simple realities to a larger, more profound experience. That this was in the mind of the photographer is supported by comments in his various writings. Whether this is apparent to all who view this image might be questioned, but certainly it would seem that this skillful rendering of a simple event has produced a mysterious and suggestive image to which many can respond.

93. Paul Caponigro (1932–). Frosted Window No. Two, Ipswich, Massachusetts. 1961.

In this image the photographer takes elements from ordinary visual experience and combines them to make a picture with mysterious power and beauty. A silhouetted tree seen through a frost-covered window would seem common enough, but because of the skill with which the composition is formed and the textures and tonalities are photographed, these things are transformed and become an event and experience complete in themselves, independent of the reality from which they came.

94. Paul Caponigro (1932–). Stonehenge. 1978.

Some subjects tend to dominate a photograph no matter how much the photographer might try to control them. The great monuments at Stonehenge fall into this category, but at the same time they are also a challenge to be met. Caponigro has spent many years in photographing Stonehenge and other early structures, and he has been able to produce a series of images that convey their mysterious strength but still function as self-sufficient pictorial statements.

This striking image attracts our attention with its dramatic composition and assumes a greater complexity of meaning as the subject is recognized.

95. George Krause (1937–). Untitled. About 1963.

This is a complex image with several possible interpretations. First, there is the subject matter, two statues seen in the windows of a building: an angel and a cherub or possibly the infant Christ. These are subjects with many levels of meaning in western culture and society that suggest this could be a statement about religious belief. It is also possible to see this as a document, showing the faith and attitudes of those who live in the building.

Or the image can be analyzed in terms of structure and composition, as one notes the visual tension between the two statues, the patterns formed across the picture surface by the areas of light found in the windows and window frames, and the movement through space set up by the angles of the building walls.

96. Jerry N. Uelsmann (1934–). Apocalypse II. 1967.

Although it is a photographic image, this is not a picture made in a camera. It is instead the result of several negatives being combined and printed together in the darkroom as a single picture. Through his unusual techniques Uelsmann reduces the dependence of the medium on observed realities and adds another dimension to its expressive potentiality. The images he produces are complex and filled with symbols and associations that cannot be completely explained. Bits and pieces from the cultural, social, and artistic ambiance come together in unexpected combinations and produce new and moving experiences, far removed from the realities upon which they are based.

97. Ralph Eugene Meatyard (1925–1972). Cranston Richie. 1964.

Working primarily during the 1950s and 1960s, Meatyard produced a body of photographic work with a complex intellectual content. His images, while unquestionably photographic in origin, are actually conceptual constructions that do not exist in the physical world, but instead in the photograph itself. By showing objects that are in themselves ordinary – a dressmaker's manikin and a mirror – with a man who has an artificial arm, Meatyard sets up a combination that moves beyond the rendered specifics to suggest unexpected relationships, and establishes a situation that cannot be explained. There is a sense of some deeper meaning here, but it cannot be described and for the most part the scene remains a mystery.

98. Garry Winogrand (1928–1984). New York. 1968.

Casual incidents from everyday life, seen and photographed in a moment like a snapshot, were a source for much of Winogrand's work.

When photographed, these informal scenes frequently suggest complex meanings that go far beyond what was present in the original event. In this image a tension is established between the playing girls and the two women – one pregnant – that suggests a larger meaning. It would be possible to try and state this more exactly, but it is probably too much a nonverbal concept to allow this. What would seem to be most important is that here the use of photography as an end in itself has become the message.

Copyright © The Estate of Garry Winogrand. Courtesy of the Fraenkel Gallery, San Francisco.

99. Garry Winogrand (1928–1984). Los Angeles, California. 1969.

During the 1960s some photographers began to work in a manner that seems to negate many basic art principles. They made images that often appear like casual snapshots, using the unorganized incidents of ordinary life for their subjects.

In spite of the informality of this photograph taken in a moment at an angle, it is still an image of great power, pulling together diverse elements like the figure in the wheelchair and the three dramatically backlighted women to create a picture that holds our attention and in its many parts reflects the complexity of all existence.

Copyright © The Estate of Garry Winogrand. Courtesy of the Fraenkel Gallery, San Francisco.

100. Larry Fink (1941–). Hotel Pierre from the *Black Tie Series*. 1977.

One of the more significant trends of contemporary photography is characterized by a style using pictorial elements associated with photojournalism and newspaper photography. Frequently characterized by the use of direct flash, it tends to produce harsh, contrasty images, with great emphasis on the subject and/or event. Often the elements of formal structure and photographic quality are deemphasized, and meaning and expression are largely contained in the interactions of the people and situations represented. Casual incidents and moments are taken out of context and given a quality of drama and meaning that may have no relevance to the facts of the actual incident. Through the process of making the photograph, a new event is created, existing and known only in terms of the forms and actions actually shown, and seemingly telling a story that cannot be fully understood.